IMAGES
of Rail

PERE MARQUETTE
1225

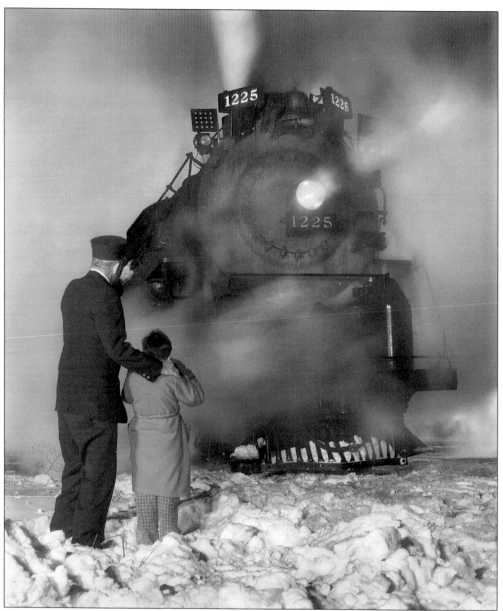

Shrouded in a cloud of her own steam, the 1225 poses during a winter photograph charter in February 2008. This image, reminiscent of the famous poster from the movie *The Polar Express*, used volunteer Fred Stevens as Mr. Conductor and coauthor T.J. Gaffney's son Thomas (then seven years old) to recreate this now-classic scene of the Christmas season. (Peter Lerro photograph.)

ON THE COVER: The Pere Marquette 1225 has a full head of steam as it powers its train near Detroit in November 1941, on one of its first revenue trips. At this time, 1225 was simply a tool of war, one of 39 locomotives used by the Pere Marquette to transport the "Arsenal of Democracy" from the war production plants to Chicago, Toledo, and other points, with eventual delivery to the Atlantic and Pacific theaters. (Courtesy of SRI; photograph by Lynn E. Taylor.)

IMAGES
of Rail

PERE MARQUETTE
1225

T.J. Gaffney and Dean Pyers
for the Steam Railroading Institute

ARCADIA
PUBLISHING

Published by Arcadia Publishing
Charleston, South Carolina

Printed in the United States of America

Library of Congress Control Number: 2014939204

For all general information, please contact Arcadia Publishing:
Telephone 843-853-2070
Fax 843-853-0044
E-mail sales@arcadiapublishing.com
For customer service and orders:
Toll-Free 1-888-313-2665

Visit us on the Internet at www.arcadiapublishing.com

*To all those who have given parts of their lives to the preservation
of the steam era through the restoration and continued operation of
Pere Marquette 1225; to quote an advertising slogan of her builder,
Lima Locomotive Works, may "steam continue to reign supreme"*

CONTENTS

Acknowledgments

We must give credit where credit is due for the idea of doing a book, although we do not know their names and may never see them again. Two supporters of Pere Marquette 1225 living on the Eastern seaboard stopped by the Steam Railroading Institute (SRI) booth at the Amherst Railroad Hobby Show, one of the largest hobby and trade shows east of the Mississippi River, in January 2013. They asked coauthor Dean Pyers a few questions about how things were going with 1225, looked over our gift shop items, and then asked, "So, do you have any books about the history of 1225?" He had to answer "No," but he immediately thought, "And why is that?" The locomotive was 70 years old by that time, and the various volunteer organizations that had restored her had a 40-year history all their own. His next decision to contact T.J. Gaffney led directly to the book you are reading today.

When writing a book of this nature, especially as a dual-author project, trying to account for all those we need to thank can be a difficult task. There are always more people than you can ever thank, but some key individuals stand out. Charles Bates and the comprehensive archives of the Allen County Historical Society in Lima, Ohio, were essential to our understanding of the history and construction process at Lima Locomotive Works, and are directly responsible for chapter one. Chris Zahrt and Zach Hall made sure we properly described the locomotives of Lima. Mac Beard from the Chesapeake & Ohio Historical Society (C&OHS) and Robert VandeVusse with the Pere Marquette Historical Society's (PMHS) collection were essential to chapter two, as well as the private collections of Walter Wilk's photographs, now part of John Kucharski's collection, and William Raia's photograph collection, now owned by Raia's son Mike. While much of chapter three came from the collection of the Steam Railroading Institute (SRI), it was founding members Aarne Frobom, Chuck Julian, and Kevin Keefe who made sure we properly documented the Michigan State Railroad Club era, assisted by Norm Burgess, Roger Scovill, Jim Sneed, John Titterton, and Jeff Wells.

We thank all of them for reviewing our document for accuracy. Finally, chapters four and five, which involved by far the toughest decisions of the book, came from a variety of suggestions from both current and past employees and volunteers of the Michigan State Trust for Railroad Preservation (MSTRP) and SRI. Without them, 1225 would never have run again, and this book could not have happened. Finally, huge thank-yous to Suzette Bromley and Chris Troy, who scanned the images; David Shorter, executive director of SRI, and librarian Bruce Omundson for access to the collections of SRI; Arcadia editors Maggie Bullwinkel and Jacel Egan, two expert conductors who kept us "on the advertised" and taught us a few things about book cover photography; and to T.J. Gaffney's wife, Heather, for improving our use of the English language and making sure the book was interesting to those not afflicted with the railroad history bug.

INTRODUCTION

In the 44 years since Pere Marquette 1225 began its second career as a working museum piece, the railroad industry has changed dramatically. In 1970, when the restoration began of the locomotive featured in this book, there were still big-city train stations and miles of rural branch lines. Small businesses had railroad sidings, there were still non-Amtrak passenger trains, freight trains had cabooses, and the cabooses carried three of the five-man crew in them. Yard offices had teletypes and switchmen, and interlocking towers had operators who recorded train movements on paper train sheets and handed up train orders on flimsy tissue paper tied with string. Freight cars had oiled journal bearings, and a few were still sided with wood. Even 20 years after the end of steam power, the railroad business was still in the steam era; the only thing missing was the steam.

But diesel engines were only the first change. Over the last 40 years, without noticing it, we have arrived in the future. Railroading in the second decade of the 21st century is nothing like it was in the 1960s, and it would not have survived if it were. It is now a hugely productive mover of bulk commodities and containerized merchandise. This is the world Locomotive 1225 now finds itself living in.

Is there room for a living steam locomotive on the railroads of the future? So far, the Steam Railroading Institute (and a handful of similar outfits elsewhere in the country) have managed to find ecological niches in which steam locomotives can continue to live and work. These niches can be temporary, and the territory is hostile, but a few big steam engines continue to thrive. But for what purpose?

The steam locomotive remains, as David P. Morgan of *Trains* magazine labeled it, "the great teacher." Anyone running a steam locomotive will forcibly learn mechanics, physics, chemistry, metallurgy, machining, and management. The people in this book learned a lot more than they expected when they undertook to run the 1225.

The locomotive is also the great attractor. As the age of steam retreats into the past, a working steam locomotive becomes an increasingly exotic sight. Firing one up attracts people on a huge scale. Among those crowds of parents and children are the railroad industry's next generation of leaders. Railroad museums are a path into an industry that is now largely out of the public eye. More than a few of the managers who guided the transition to modern railroading got their start as railfans or railroad museum volunteers.

But the locomotive only attracts and teaches if it runs. A stuffed-and-mounted museum piece will not cut it.

This is why the enormous cost and effort of making the 1225 run is worth it. The main problems in keeping the 1225 running are not mechanical. Although the 1225 was not in good shape when it was delivered to the Michigan State University campus in 1957, its problems could all be fixed by the usual methods. All its restorers had to do was find the defects and learn and practice the traditional skills. That proved to be the easy—and fun—part. The real challenge is institutional: building the support needed to keep a machine in operation 60 years after it should have passed into oblivion.

The first challenge was finding the money. No one was really keeping track of how much money was contributed by early supporters of the 1225 project, but the idea of making a steam locomotive run in the 1970s motivated a steady flow of contributions from steam fans nationwide. Over 20 years, that was enough to let the engine run again, if sporadically, at a cost of well over half a million dollars. In 2012 and 2013, the locomotive got the new firebox it needed in 1951. It is the third super power locomotive to have a new firebox made in this century, and that job cost over $900,000. And yet, more work remains.

But raising the money is only half the challenge. The other half is making use of the enthusiasm and skills that volunteers bring to the project. Railroads got rid of steam power because it took so many people to keep it running. The machine's demand for labor is unchanged today, but labor costs are far higher. Luckily, the machine's appeal to people eager for a challenge is unchanged, too. The 1225 is operated by dozens of volunteers who frequently say, "You couldn't pay me to do this." Steam engines will continue to run as long as people want them to, and people have wanted to keep the 1225 running for 44 years. So far.

What are the results?

In another great David P. Morgan phrase, "somewhere in the consciousness of every American is the image of a steam locomotive." Like the Mississippi steamboat, the Conestoga wagon, the Ford Model T, or the Saturn rocket, the steam train is part of the soul of a nation that has never stopped going places. These images should not be allowed to slowly vanish, or turn into cartoons. People need to experience history viscerally instead of virtually, to see firsthand how things used to be along the road to how things are now. The huge, black, steaming machine is the ultimate symbol of power, precision, and capability. People deserve to be able to return to the source of this image, for its power to inspire.

—Aarne H. Frobom

Aarne H. Frobom is the president of the board of directors of the Steam Railroading Institute, of which he is Member No. 7. He is a transportation planner for the Michigan Department of Transportation and lives in Haslett, Michigan.

One

LIMA BUILT

The company that became the Lima Locomotive Works began as the Lima Agricultural Works in 1869. Like many other midsized machine shops, Lima Agricultural ventured into the growing market for steam-powered machinery with a line of sawmill equipment. Lima's first industrial switching locomotive appeared in 1878, but it was their partnership with Ephraim Shay that made Lima a successful producer of railway locomotives. Shay had developed a geared locomotive for his logging operation in northern Michigan, and it worked so well in that low-speed, heavy-hauling environment that one of his neighbors asked Shay to produce a copy. Shay was not interested in entering the manufacturing business, but since he had worked with Lima Agricultural in the past, he allowed Lima to make additional copies of his locomotive design. Lima expanded and improved the design, eventually building 2,761 of the geared locomotives, which became very popular with logging and mining companies.

Lima expanded their shop capacity and their products beyond the geared locomotives to include more conventional rod-driven road engines in the early 1900s. Financial problems in 1916, however, allowed the company to be taken over by Joel S. Coffin and Samuel G. Allen, two businessmen who controlled a variety of other railroad suppliers. Coffin's Franklin Railway Supply experimented with appliances that enhanced locomotive efficiency, producing more power in the same-sized locomotive while using less fuel. Between 1902 and 1915, they brought to market improved feed-water heaters, booster engines, superheaters, and firebox components. Once Coffin and Allen controlled Lima Locomotive, they partnered with renowned engineer William E. Woodard and incorporated many efficiency improvements, which resulted in Lima's "Superpower" designs. Interestingly enough, Coffin had several other ties to the Pere Marquette, having been born in St. Clair County, Michigan, in 1861, and worked as a machinist's apprentice for Pere Marquette predecessor Chicago & West Michigan at age 19.

Lima would become one of the largest locomotive builders during the heyday of steam, trailing only the massive Baldwin Works of Philadelphia; the consortium of midsized East Coast shops such as Brooks, Cooke, and Rogers that merged together to form American Locomotive (ALCO) of Schenectady, New York; and the H.K. Porter industrial locomotive company of Pittsburgh. In the 72 years that passed between Lima's first Shay in 1879 and the last diesel in 1951, "the Loco" manufactured over 7,500 locomotives, including 4,787 direct rod-driven steam engines similar to PM 1225.

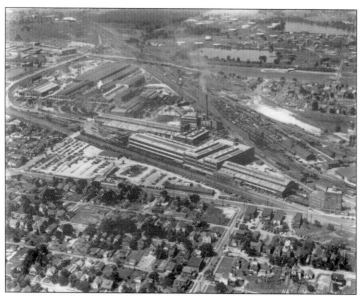

Lima Locomotive moved from smaller quarters near downtown Lima, Ohio, to this sprawling shop complex on South Main Street in 1902. The shops covered 67 acres on Lima's south side, bordered by the Nickel Plate Railroad to the north and west and the Baltimore & Ohio on the east. The Erie Railroad also passed just north of the complex. (Courtesy Allen County Historical Society.)

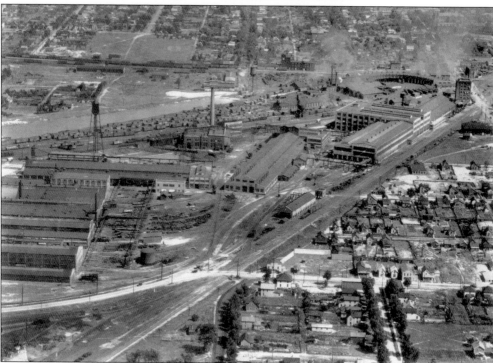

In this view looking north, the large Nickel Plate (formerly Lake Erie & Western) Railroad roundhouse and classification yard can be seen on the northern edge of the Lima property. The Baltimore & Ohio line between Cincinnati and Toledo (formerly the Cincinnati, Hamilton & Dayton) passes between the shop complex and the houses at the lower right corner of the photograph. The Erie Railroad crosses just south of the houses at the top of the photograph. Employment typically hovered around 2,500 people, and peaked at over 4,000 during World War II, when the complex was producing not only steam locomotives but also Sherman tanks and a popular line of construction cranes. (Courtesy Allen County Historical Society.)

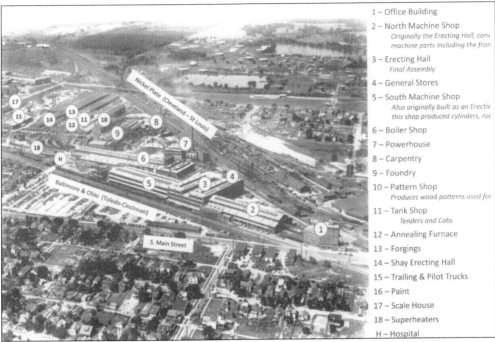

1 – Office Building
2 – North Machine Shop
 *Originally the Erecting Hall, conv
 machine parts including the fran*
3 – Erecting Hall
 Final Assembly
4 – General Stores
5 – South Machine Shop
 *Also originally built as an Erectin
 this shop produced cylinders, roc*
6 – Boiler Shop
7 – Powerhouse
8 – Carpentry
9 – Foundry
10 – Pattern Shop
 Produces wood patterns used for
11 – Tank Shop
 Tenders and Cabs
12 – Annealing Furnace
13 – Forgings
14 – Shay Erecting Hall
15 – Trailing & Pilot Trucks
16 – Paint
17 – Scale House
18 – Superheaters
H – Hospital

Production departments on the shop complex were organized in separate buildings, with the process starting in the foundry, machine shops, or subassembly areas and culminating in the erecting halls at the northeast corner of the property. An extensive array of railroad tracks moved components between buildings and was used for final testing of completed locomotives. Shown here is an overhead photograph with buildings labeled as to their location and use in the complex. (Courtesy Allen County Historical Society.)

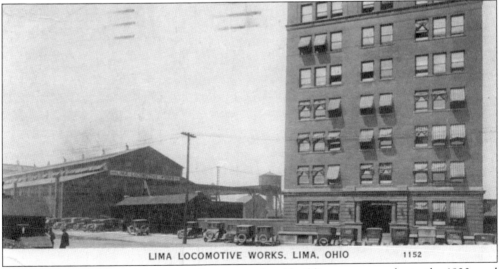

LIMA LOCOMOTIVE WORKS, LIMA, OHIO 1152

Postcard photographs and drawings of important local buildings were popular in the 1920s and 1930s and were an inexpensive way of keeping in touch with friends and relatives before the days of cell phones and e-mail. This street view photographic postcard was mailed from Columbus back to Lima in 1936. Note the open windows, shades, and lack of air conditioning in the office building. (Courtesy Dean Pyers collection.)

11

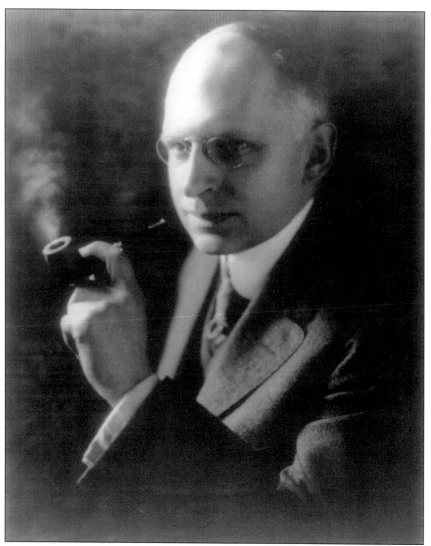

The father of Superpower steam was William E. Woodard. Born on November 18, 1873, in Utica, New York, he graduated with a mechanical engineering degree from Cornell. Woodard worked for locomotive builders Baldwin, Dickson, and Schenectady before becoming chief draftsman, manager of electric locomotives, and assistant mechanical engineer for ALCO between 1900 and 1916. As vice president of engineering at Lima, his 1925 design of the first 2-8-4 Berkshire introduced the concept of Superpower, or "power at speed," producing more steam than it could consume. Awarded more than 100 patents for lightweight trucks, locomotive throttles, superheater header arrangements, valve gear, poppet valve cylinders, and force-fed circulation boilers, he was named a "Modern Pioneer" by the National Association of Manufacturers in 1940. He died from a heart condition in his Forest Hills, New York, home on March 24, 1942. As he was still affiliated with Lima as a corporate director, many company officials traveled to Long Island for his funeral, as noted in the local paper. Will Woodard's Superpower designs made it possible for an engineer living on Long Island to stay involved with a manufacturer in Lima, Ohio, well before the days of telecommuting and express air travel. Woodard, his engineers, or a box of blueprints could board Pennsy's "Red Arrow" in Manhattan at 4:00 p.m. and arrive in Lima before 6:00 a.m. the following day. (Courtesy Allen County Historical Society.)

THE PILLIOD COMPANY
SWANTON OHIO

VALVE MOTION REPORT **BAKER VALVE GEAR**

Road Pere Marquette Gears Applied At Lima, Ohio Type of Admission Inside

Engine No. 1227 Valves Set, date 3-17-44 Valve Diam. 14"

R.R.Class N-2 Builders Name Lima Loco. Wks. Valve Travel 8"

Type 2-8-4 Builders Serial No. 8452 Steam Lap 1-43/64"

Driver Diam. 69" Builders Order No. 1189 Lead 1/4"

Cylinders 26 X 34" Builders Shop No. #3 Exhaust Clea. 1/16"

Type of Gear Long Lap TPCO Gear No. 13764 Crank Circle 25"

Type of Reverse Precision Type of Valve Piston Length of Crank 22-3/8"

Reverse Yoke Positions A - B		Cut-Off Per.Ct	Cut-Off		Release		Comp. or Closure		Preadmission		Lead		Port Opening	
			Front	Back	Front	Back	Front	Back	Front	Back	Front	Back	Front	Back
14 7/8	FORWARD MOTION Right	25	8 1/4	8	23 3/8	22 1/2	10 1/2	9 1/2	5/8	1/2	1/4	1/4	13/32	7/16
14 1/4		33	11 1/2	10 7/8	25 5/8	24 1/4	9	8	7/16	3/8	"	"	1/2	1/2
13		50	16 7/8	17	28	27 3/8	6 3/8	5 5/8	1/4	3/16	"	"	25/32	15/
11 3/8		66	22 3/8	22 3/8	30 1/4	30	4	3 3/4	3/16	1/8	"	"	1 5/16	1 1/16
9 15/16		Full Gear	27	26 5/8	31 3/4	31 3/8	2 1/2	2	0	1/32	"	"	2 1/16	2 3/16
	FORWARD MOTION Left	25	8 3/4	8	24	22	10 5/8	9	5/8	3/8	1/4	1/4	13/32	1/32
		33	11 1/4	10 1/4	25 5/8	24	9 1/8	7 1/4	7/16	3/8	"	"	1/2	1/2
		50	17	16 5/8	28 1/4	27	6 1/4	5 5/8	1/4	3/16	"	"	13/16	15/16
		66	22 3/4	22 3/4	30 3/8	30	3 7/16	3 3/8	3/16	1/8	"	"	1 3/8	1 1/16
		Full Gear	27	26 3/4	31 3/4	31 1/2	2 3/8	2	0	1/32	"	"	2	2 5/8
18 3/8	BACKWARD MOTION Right	25	8 7/8	8	24 1/4	22 1/2	10 7/8	8 7/8	5/8	1/2	1/4	1/4	7/16	7/16
19		33	11 1/4	10 1/4	25 1/2	24 1/4	9 1/8	7 1/4	7/16	3/8	"	"	1/2	1/2
20 1/4		50	16 1/8	16 5/8	28 1/8	27 1/8	6 1/8	5 1/8	1/4	3/16	"	"	23/32	15/32
24 1/16		Full Gear	27 1/4	27 1/4	32	31 1/8	2 1/4	2	0	1/32	"	"	2 1/16	2 1/16
	BACKWARD MOTION Left	25	8 3/4	8	24 1/8	22 1/8	10 7/8	8 7/8	5/8	3/8	1/4	1/4	7/16	7/16
		33	11 1/2	10 7/8	26	24 7/8	9 1/4	7 5/8	1/2	3/8	"	"	1/2	15/32
		50	17	16 1/2	28 1/2	26 5/8	6 1/2	5 5/8	1/4	3/16	"	"	23/32	3/4
		Full Gear	27 5/8	27 1/4	32	31 1/4	2 3/8	2	0	1/32	"	"	2 1/16	2 3/16

Mid-Gear Position	
Type Gear	C
Standard	12-7/8
Long Travel	16-3/16
Long Lap	16-9/16

Report First Engine Complete — Others at Running Cut-off.

One Copy to N.Y.Office and Mech.Engr. Office
One Copy to Chicago Office

Specified steam lap is 1-11/16" twice this amounts to 3-3/8" over all. The over all steam lap on this engine measures 3/64" under 3-3/8" causing lead to show heavy.

VALVES SET BY _[signature]_
H. D. _[signature]_

While Lima built many components itself, the industry was also supported by a large supply base, not unlike today's automotive industry. Steel came from Otis Steel in Cleveland, safety appliances from Nathan in New York, superheater tubes from Elesco, rear truck frames from Buckeye Castings in Columbus, air compressors from Westinghouse, feed-water heaters and pumps from Worthington, and so on. Each of these suppliers maintained their own engineering and sales staffs and had competitors bidding against them for new business within the locomotive industry. The Pilliod Manufacturing Company of Swanton, Ohio, was one such supplier. Abner D. Baker built steam tractors in Swanton and invented a new and improved valve gear design. The valve gear mechanism controls the direction and power output of the locomotive, and Baker's design simplified it by eliminating complex links and replacing them with bushings that required less maintenance. It also provided for a more efficient use of steam, which was the main goal of Woodard's Superpower concept. This form shows all the measurements and calculations regarding the motion of the valve gear, as installed on the first Pere Marquette N-1 series locomotive, No. 1216. (Courtesy Allen County Historical Society.)

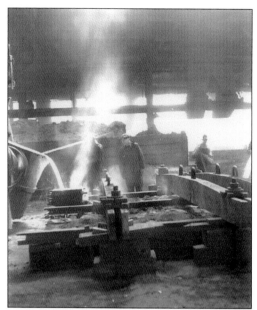

Manufacturing processes begin in the foundry, where molten metal is poured into molds to form various shapes and components. Shown here is a "pit" mold, with liquid metal being poured from bull ladles. Large bolts cast into the concrete surrounding the pit hold cross beams that prevent the pressure of the metal from lifting the cope (formed cover) up and causing either a run-out or a casting that has a lot of flash, which is the wrong thickness. The crane, seen here, positions the bull ladle. The hand wheel on the side of it is geared, and, when it is turned by the pour-off man, the ladle tilts. He controls the rate of flow from the ladle into the sprue, which feeds the mold. The metal is hot enough that the pour-off men use dark-colored goggles to prevent damage to their eyes. (Courtesy Allen County Historical Society.)

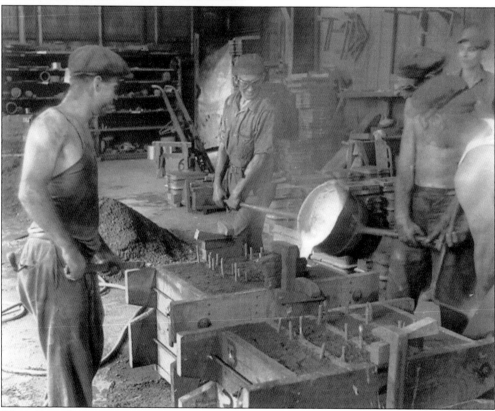

"Green" sand covering the concrete floor, hot metal, sand molds, sweat, and dust—such is the life of the foundry man almost anywhere in the world. In this photograph, Lima employees are pouring either aluminum or zinc, as evidenced by the steel ladle with the two-man ring shank and the color of the metal. (Courtesy Allen County Historical Society.)

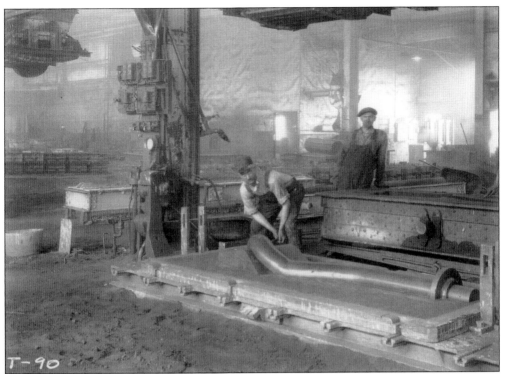

A wood pattern sits in a drag (lower) mold after sand has been shaped around the pattern. Soon, the cope flask (upper mold) will be hoisted into place on top of the drag; sand will be filled and compacted into the cope; the halves will be separated and the wood pattern removed. The halves are then reassembled, molten metal is poured in, and once the casting cools the halves are separated again and the cast part can be moved to other buildings for further machining and processing. Like everything in the foundry, this was heavy, dirty work. (Courtesy Allen County Historical Society.)

Forging operations take hot or cold metal and form it into a shape using a heavy drop hammer. Employing the same techniques that a blacksmith would use, albeit on a much larger scale, these teams of men working in the forging department made such parts as driving rods. (Courtesy Allen County Historical Society.)

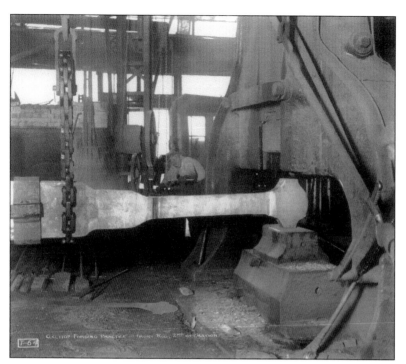

In a similar view, a man uses the drop hammer to form a portion of a driving rod. From here, the formed rod would be sent elsewhere in the complex for further shaping and machining. (Courtesy Allen County Historical Society.)

No electronic tools or computer-aided design drawing programs were used here; these specifications were created by engineers using T-squares, compasses, mechanical pencils, and slide rules. Each component on the locomotive had detailed blueprints that defined the key characteristics of the part and instructed the machinists how it was to be made. This page details the intermediate driving rods used in Lima order 1143, the first series of PM Berkshires (1201–1215). This form was created on March 8, 1937, and the locomotives were built in the fall. Note the small check marks next to each calculation, indicating that the engineer or a drawing supervisor reviewed all of the calculations and checked them for accuracy. (Courtesy Allen County Historical Society.)

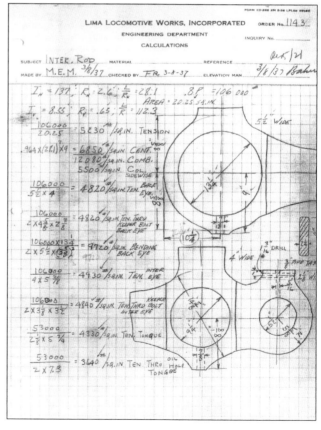

Heavier parts were moved between buildings in the shop complex using internal railcars, which were likely built by the shop complex itself. These side rod castings would move between the forge and the machining shops. Note that the flatcar has no couplers and probably no brakes. Cars that were used only internally on a manufacturing site and would not leave the property for interchange to a railroad could be outfitted quite differently than a normal freight car. (Courtesy Allen County Historical Society.)

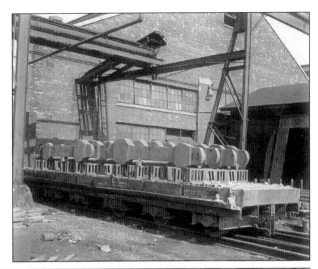

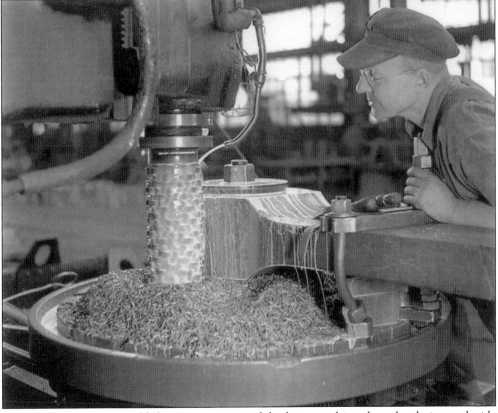

Castings and forgings would then move to one of the large machine shops bordering each side of the final assembly hall. Here, the raw metal parts went through milling, drilling, boring, and other operations to refine them to their final shapes and precise dimensions. A machinist carefully watches as his milling tool cuts metal off the exterior of the driving rod. Cutting fluid is poured onto the mill head to cool the cutter and take away chips. This fluid collects at the base of the work table, is filtered, and is then recycled through the machine. (Courtesy Allen County Historical Society.)

In this photograph, a Lima worker trims the corner edge off of a connecting rod using an air chisel cutting tool. Safety glasses and other modern protective gear were apparently not required in the area where this photograph was taken in the 1930s. (Courtesy Allen County Historical Society.)

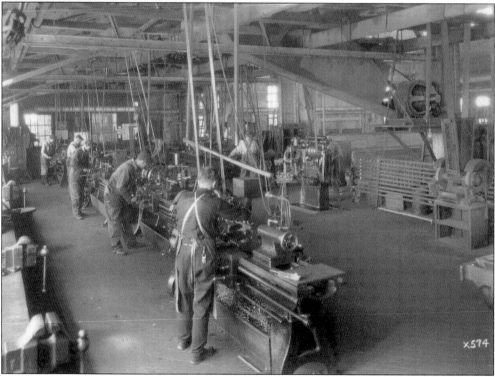

A central tool room on the second floor of Building 5 supported the entire complex. Using lathes and other machinery, toolmakers would create gauges, jigs, and fixtures used to assemble and inspect components produced elsewhere on the complex. Note the belt-driven machines powered from a central large electric motor at the right of this photograph, taken on April 19, 1927. Eventually, the central belt drive system would be replaced by individual electric motors on each machine. (Courtesy Allen County Historical Society.)

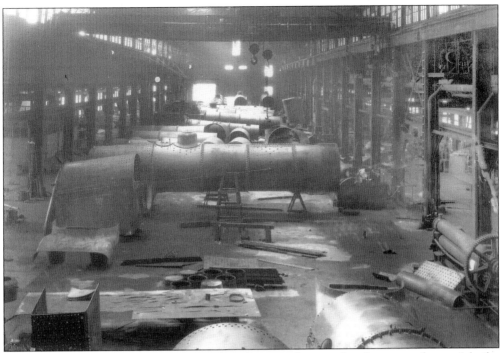

Controlled chaos may be the only way to describe most photographs of any manufacturer's boiler shop. This was the heart of the operation, and the precision of boiler construction was a source of great pride to Lima. Flat sheets of steel are rolled into cylindrical shapes, the firebox is assembled using hand tools, and the boiler sections (known as courses) were fitted inside each other and riveted upright using bull riveters. Here, there are several boilers in various stages of completion, with rolled sections ready to be added, and a profile of how boilers become smaller going forward as the next course is fitted inside the last. (Courtesy Allen County Historical Society.)

Bull riveters are large C-shaped machines that apply far more force than two men could ever apply using hand tools. The base of the riveter is anchored to the floor, and the open jaws extend 20 or more feet into the air. Overhead hoists drop the boiler into the riveter, with one side of the boiler placed between the jaws. Operators on the platform place a hot rivet into pre-aligned holes, activating the bull riveter to flatten the rivet on both sides. When the rivet cools, it draws the metal together even more. (Courtesy Allen County Historical Society.)

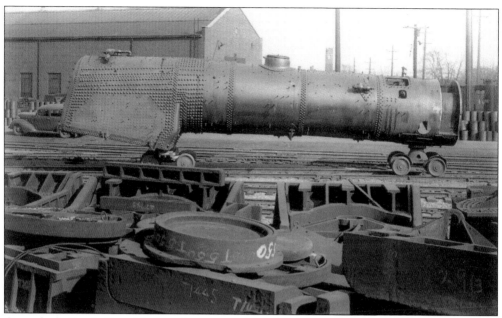

Once the boiler shell and firebox sheets were riveted together, the completed boiler was moved across the complex using the in-plant rail network and these small transfer wheel sets known as "dolliers." As is typical with most rail yards, a considerable amount of clutter and surplus metal resides trackside and along the outside walls of the buildings. (Courtesy Allen County Historical Society.)

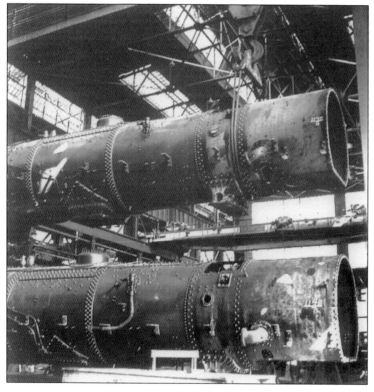

Final assembly occurred inside the erecting halls, where large overhead cranes would move the boiler assemblies over other locomotives and position them on their frame. Here, the eighth boiler of order 1148 passes over the seventh boiler of the same order. Each boiler was later affixed with a serial number and a diamond-shaped builder's plate. PM 1225's serial number is 7839. (Courtesy Allen County Historical Society.)

The erecting hall is where everything came together. Castings and machined parts were assembled, mated to the boiler shells, and outfitted with cabs, internal and external piping, and operating controls and appliances purchased from suppliers. In this photograph from March 1944, a PM-class N-2 Berkshire frame from Lima order 1180 awaits its boiler delivery from overhead, while two of its siblings have already received their boiler. (Courtesy Allen County Historical Society.)

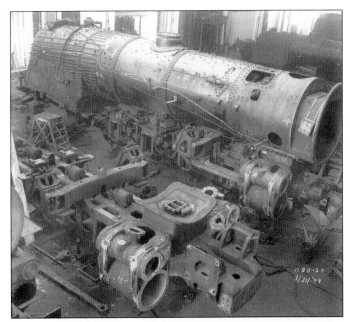

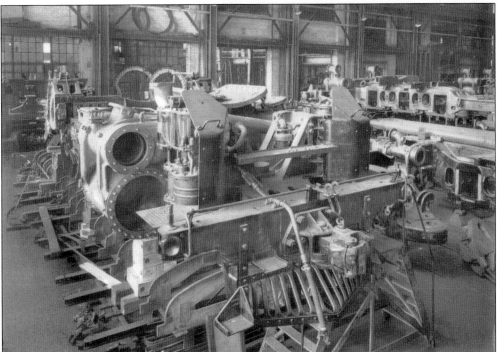

This is another view of the erecting hall floor at Lima, with a series of frames receiving air-compressor pumps, valve gear, front pilots, and couplers. Cast into the frames on these locomotives and seen in the photograph is a circular indentation on each corner known as a "poling pocket." Poling pockets on locomotives and freight cars received the ends of long wooden poles that switch crews would hold in place to move a car on a track adjacent to the locomotive. It was a rather dangerous procedure, and it has not been used in quite some time. (Courtesy Allen County Historical Society.)

The size and scope of the erecting hall bays can be seen in this photograph, as workmen scale the 16-foot-high boilers on frames while overhead cranes and additional overhead structures soar above them. Final assembly took approximately three weeks to complete. (Courtesy Allen County Historical Society.)

In another part of the complex, the tank shop produced the locomotive tenders. These support cars carry coal and water for the locomotive. In the case of the Pere Marquette's Berkshire, these tenders carry up to 22,000 gallons of water and 22 tons of coal when fully loaded. (Courtesy Allen County Historical Society.)

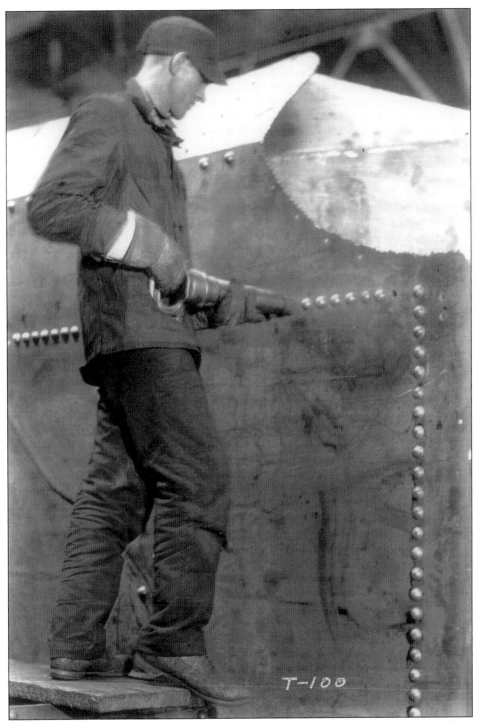

T-100

Lima employee Earl Archer applies rivets to sheets of steel to form the various tanks and compartments inside the tender. The coal and water carried in PM 1225's tender is enough to power the locomotive for roughly 100 miles for the water and 200 miles for the coal with a heavy train. (Courtesy Allen County Historical Society.)

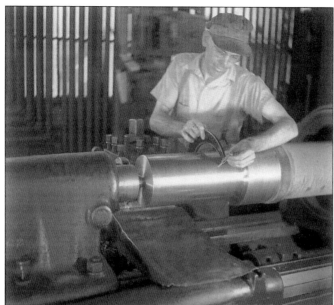

In addition to the heavy, dirty jobs in the factory, there were also tasks that required precision measurements or laboratory tests. In this image, an employee measures the diameter of a machined part, possibly a connecting pin, for accuracy. (Courtesy Allen County Historical Society.)

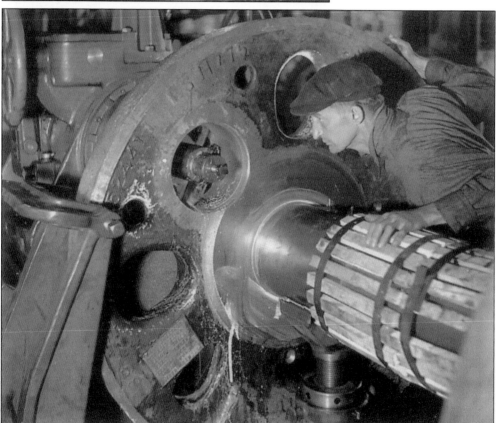

Driving wheels were cast, machined, and pressed onto axles to form an axle assembly. In this photograph, a machinist carefully watches as a cutting tool shapes the hole for the crank pin into a driving wheel. (Courtesy Allen County Historical Society.)

In this image, the completed drive wheel assembly is shown, with connecting pins also in place. From here, the wheel would be sent to the erecting hall to be inserted into the drive wheel boxes. These would then be inserted into the frame of the locomotive. (Courtesy Allen County Historical Society.)

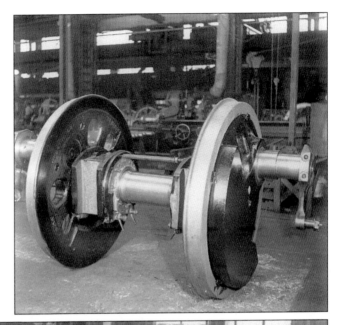

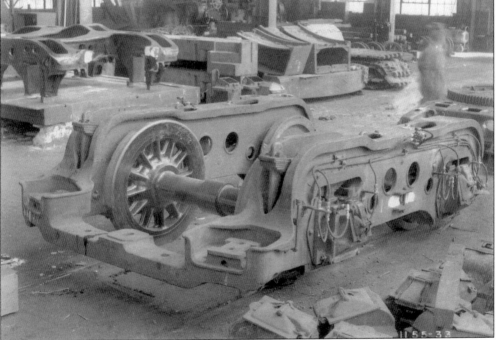

The truck shop at Lima assembled wheels and axles into the front and rear truck assemblies for the steam locomotives. In this photograph, a trailing truck sits ready to be transported to the erecting hall to be placed under the firebox and cab of a locomotive. This trailing truck has a bulge in the middle of the visible axle. If the locomotive was ordered with a booster engine, a gear would be pressed over this bulge to drive the rear axle. The N-1 engines did not have boosters, but the trucks were made so that one could be added. Some of these parts were cast at Lima, while other parts such as the sides of the truck were cast by other foundries and shipped to Lima for final assembly. (Courtesy Allen County Historical Society.)

LIMA LOCOMOTIVE WORKS, INCORPORATED
ENGINEERING DEPARTMENT
REPORT OF BOILER STEEL
BUILT BY LIMA LOCOMOTIVE WORKS FOR *Pere Marquette R.R.Co.*

ENGINE No. 7839
ROAD No. 1225
CLASS 2-8-4
ENG. ORDER 1155 #10

SIZE	SERIAL	HEAT	SLAB	Elastic Limit	Tensile Strength	Elongation in 8 in.	Car.	Man.	Phos.	
FIRE BOX										
Crown	638	21138		38540	55640	30	18	38	014	04
R. Side	655	1381		43270	61800	28	16	36	018	04
L. Side	652	23837		36690	58510	26.50	17	40	011	04
Tube	618	24450		35380	57060	31	16	37	018	04
Back	742	24513		37730	57540	24.50	18	33	022	03
Combustion Chamber	680	6219		33450	58570	29	18	33	008	04
Inside Throat	670	23845		37230	58140	28.50	19	36	010	0
SHELL										
Front Tube	473	23777		37170	56630	32.50	22	40	020	03
First Ring	744	23716		36480	56630	31	23	34	011	0
" Weld O.S.	509	21041		36730	60580	28	24	40	013	04
Second Ring	353	23849		36850	58300	30	24	44	020	03
" Weld O.S.	517	21041		37280	60480	28	24	40	013	02
" I.S.	528	25937		37280	62800	26.50	20	39	021	03
Third Ring	959	23832		36130	57030	30	25	50	019	02
" Weld O.S.	539	25931		39350	62290	26	23	39	021	0
" I.S.	557	23926		36580	58460	26	23	38	015	0
Dome Base / Dome / Dome Ring	591	23812		38930	57360	29	20	36	011	04
Rest	436	23914		38560	56710	33	22	46	016	04
R. Side	458	21030		35170	58960	24.50	24	37	018	04
L. Side	443	25887		38740	59000	29	23	40	022	03
Throat	593	23800		36560	56360	29.50	21	37	014	04
Back Head	485	23801		36260	57720	30	22	34	011	03
Dome Liner	12033	24589		38320	57810	33	22	38	012	04

OCT 15 1941

FIRE BOX STEEL FROM *Otis Steel Co.*
BOILER STEEL FROM *Otis Steel Co.*

O.B. Schultz
Chemist and Engineer of Tests

Detailed laboratory tests were conducted on incoming material, including the steel received for various parts of the boiler. This page from October 15, 1941, summarizes all of the tests performed on samples of steel received from Otis Steel Corporation and used on Lima serial number 7839, the 10th locomotive of order 1155, numbered Pere Marquette 1225. (Courtesy Allen County Historical Society.)

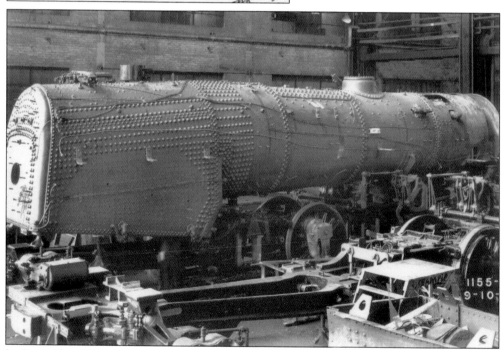

In September 1941, the first components of 1225 and her 11 sister locomotives from order 1155 began to arrive at the erecting hall. Frames, driving wheels, valve gear, and a boiler assembly are all visible in this photograph. (Courtesy Allen County Historical Society.)

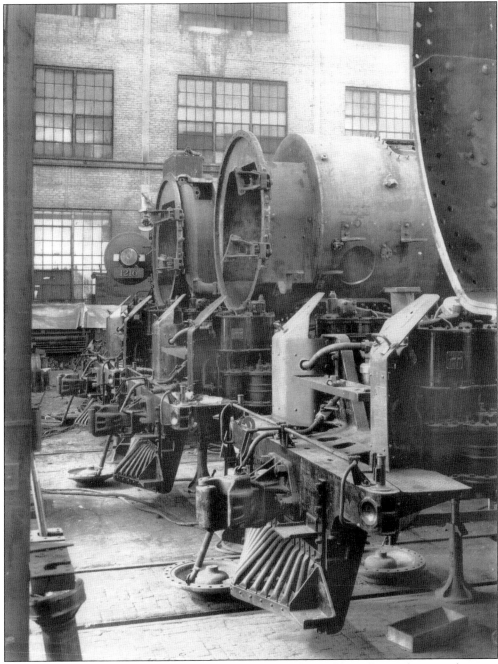

Four locomotives from order 1155 exhibit various stages of assembly as they strike a proud pose in the erecting hall. No. 1216, the first of the PM N-1 series, has its headlight and smokebox doors attached at the far end of the photograph. (Courtesy Allen County Historical Society.)

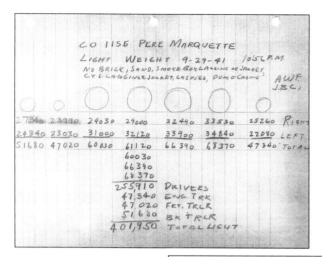

At 10:56 p.m. on September 29, 1941, the first Pere Marquette Berkshire arrived in the scale house at Lima. Now real measurements could be taken to compare with the engineering calculations done earlier in the spring. Employees "A.W.F." and "J.B.C." completed the weighing and recorded their observations on a piece of paper, which, thanks to the foresight of a few Lima retirees, still survives in the archives of the Allen County Historical Society. (Courtesy Allen County Historical Society.)

Accountants also existed in the 1940s, and they required a detailed reporting of the hours accumulated on each locomotive order. At the end of order 1155, this report was prepared, comparing the original estimate of hours that would be needed by each shop department to complete the 12 Berkshires for the Pere Marquette to the actual number of hours recorded against the order. The company could then use these figures to improve their price quotes or work on efficiencies in certain departments. Note that the boiler shop exceeded their estimated hours—by 1,225 hours (5,168 actual compared to 3,943 estimated). (Courtesy Allen County Historical Society.)

DIRECT LOCOMOTIVE COST-ESTIMATE vs. ACTUAL
BASIS ONE (1) LOCOMOTIVE

12 LOCOS FOR Pere Marquette Ry. Co.
SHOP Nos. 7830-7841 ENG. TYPE 2-8-4 ORDER No. 1155
CYL. 26"x34" GAUGE 4'8½" ENG. WT. EMPTY 402 600
TENDER TYPE 12wh.22,000 GalTANK Rectangular
FUEL 22 Tons Coal TENDER WT. EMPTY 134,400
TOTAL WEIGHT ENGINE AND TENDER EMPTY 537,000
VALVE MOTION "Baker" BOILER Conical Conn.
SUPERHEATER Type "E" CAB Steel
DATE OF ORDER Jan. 28, '41 SHIPPED Nov. 7, '41

MATERIAL	WEIGHTS ESTIMATE	ACTUAL	AMOUNT ESTIMATE	ACTUAL
Forgings, Bar	18 607	14 306	759	416
Hammered	35 220	31 216	2 102	2 072
Special	23 710	32 747	1 535	1 946
Total Forgings	77 537	78 269	4 396	4 613
Castings, Steel	130 290	133 033	12 255	12 393
Malleable	50	34	13	6
Brass	1 035	1 231	253	260
Bearings	7 150	6 731	1 453	1 400
Iron	5 980	5 155	343	382
Special G.I.	4 675	4 658	305	306
Total Castings	149 240	151 162	14 619	14 747
Other Material			14 088	13 359
Specialties			40 033	40 257
Total Material			73 136	72 975

LABOR	ESTIMATE	ACTUAL	EXCESS IN ESTIMATE	ACTUAL
Smith Shop	493	441	52	0
Boiler "	3 943	5 168	0	1 225
Tank "	1 401	1 636	0	235
Truck "	313	290	23	0
Mach. Shop 8	653	750	0	97
" " 9	783	957	0	174
" " 10	1 028	1 292	0	264
Erecting	2 718	3 012	0	294
Mach. Shop 12	83	139	0	56
Carpenter	42	65	0	23
Paint	158	154	4	0
Bolt Room	90	85	5	0
Misc.				
Total Labor	11 705	13 989	0	2 284

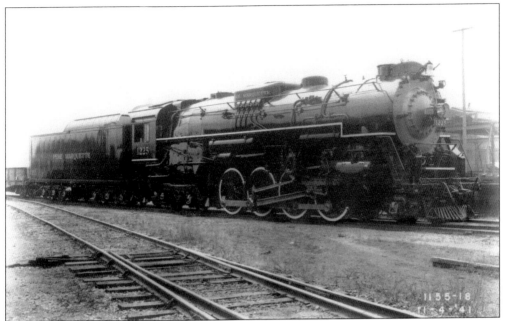

Builder's photographs were very common during the steam era. As each engine was completed and rolled out of final assembly onto testing tracks for its first fire-up and final inspections, the company photographer would often take images of the locomotive from all sides. PM 1225 poses for the photographer in these November 4, 1941, photographs. (Courtesy Allen County Historical Society.)

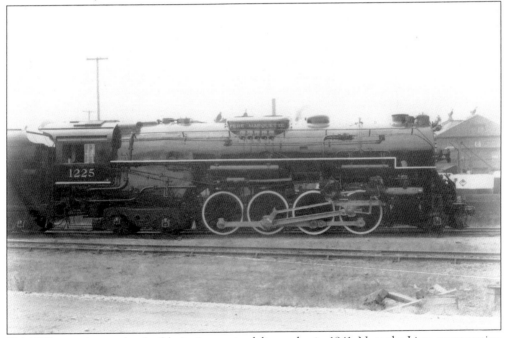

PM 1225 poses in another builder's view on its delivery day in 1941. Note the Lima construction crane in front of Building 6 in this photograph, one of the many cranes that Lima built. (Courtesy Allen County Historical Society.)

I. C. C. Form No. 3.

ANNUAL LOCOMOTIVE INSPECTION AND REPAIR REPORT

Form L-128 CNP

NOV 4 - 1941, 19.... C.O. 1155-105-7830

Locomotive { Number **1225** / Initial **PLH.**

PERE MARQUETTE RAILWAY COMPANY

In accordance with the act of Congress approved February 17, 1911, as amended March 4, 1915, and the rules and instructions issued in pursuance thereof and approved by the Interstate Commerce Commission, all parts of Locomotive No. **1225**, including the boiler and its appurtenances, were inspected on **NOV 4 - 1941**, 19...., at **Lima, Ohio**, and all defects disclosed by said inspection have been repaired, except as noted on the back of this report.

1. Date of previous hydrostatic test **New Boiler**, 19....
2. Date of previous removal of caps from flexible staybolts, **New Boiler**, 19....
3. Date of previous removal of flues **New Boiler**, 19....
4. Date of previous removal of all lagging **New Boiler**, 19....
5. Hydrostatic test pressure of **334** pounds was applied.
6. Were caps removed from all flexible stay bolts? **No. 23B. Buff**
6a. Were all stay bolts hammer tested under hydrostatic pressure? **Yes**
7. Were all flues removed **New** Number removed **None**
8. Condition of interior of barrel **Good.**
9. Was all lagging removed? **New Boiler**
10. Condition of exterior of barrel **Good**
11. Was boiler entered and inspected? **Yes**

12. Was boiler washed? Water glass cocks and gauge cocks cleaned? **Yes. Yes.** Water column connection **Yes.**
13. Condition of crown stays and staybolts **Good. Good.**
14. Condition of sling stays and crown bars **Not used. Not used**
15. Condition of firebox sheets and flues **Good. Good.**
15a. Was new firebox applied? **New Boiler**
16B. Condition of arch tubes **Good.** Water bar tubes **Not used**
17. Condition of throat braces **Not used.**
18. Condition of back head braces **Good.**
19. Condition of front flue sheet braces **Good.**
20. Were fusible plugs removed and cleaned? **Not used.**
20a. Give make and condition of low water alarm **Nathan "B" Goo**
21. Were steam leaks repaired? **Yes**

Items 1 to 21 and 26. I certify that the above report is correct. *G.C. Myers*, Inspec

22. Were steam gauges tested and left in good condition? **Yes**
23. Safety valve set to pop at **245** pounds, **248** pounds, **251** pounds.
24C Were both injectors tested and left in good condition? **Yes**
25. Were steam leaks repaired? **Yes**
26 D Hydrostatic test of **210** pounds applied to main reservoirs.

27. Condition of brake and signal equipment **Good. Not used.**
28. Were drawbar and drawbar pins removed and inspected **New. New.**
29. Condition of draft gear and draw gear **Good. Good.**
30. Condition of driving gear **Good.**
31. Condition of running gear **Good**
32. Condition of tender **Good.**

Items 12 and 22 to 32. I certify that the above report is correct. *C.W. Keller*, Inspe

STATE OF **Ohio** } ss:
COUNTY OF **Allen** }

16B Two arch tubes, two syphons.
24C One injector and one Worthington F.W. Heater
26D Builders test.

Subscribed and sworn to before me this **NOV 4 - 1941** day of, 19...., by { *G.C. Myers* / *C.W. Keller* } Inspectors of

Lima Locomotive Works, Inc. Company. My Commission Expires May, 30 1944

The above work has been performed and the report is approved. Notary Pu, Officer in cha

The first of many Interstate Commerce Commission Form 3 reports that would be completed for PM 1225 during its career, the initial inspection report from November 4, 1941, certifies that the locomotive was fully inspected and ready for service. G.C. Myers and C.W. Keller completed the inspection, and a notary public (presumably also a Lima employee) certified the event. (Courtesy Allen County Historical Society.)

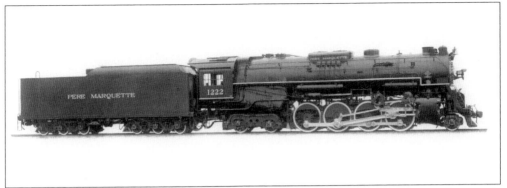

This profile view of Pere Marquette 1222 represents the official Lima construction photograph representing the N-1–class locomotives. These builder's photographs, or "cards," also included detailed information about the specifications of this class, serving as a sort of business card for Lima and the Pere Marquette. (Courtesy T.J. Gaffney collection.)

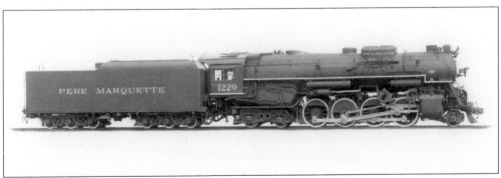

In a similar view, Pere Marquette 1229 shows the next and final order (1180) of Pere Marquette Berkshires, class N-2. Although essentially the same locomotives as the previous two 1937 and 1941 orders, the final 1944 order of Pere Marquette Berkshires shows the influence of the upcoming merger of the PM with the Chesapeake & Ohio. Most noticeable is the relocated and smaller sand dome, now placed ahead of the steam dome, per C&O practice. Five units of this order also had a booster engine powered through the trailing truck for heavy train loads. (Courtesy T.J. Gaffney collection.)

No longer used for production and quieter than it was 50 years earlier, Michigan State Trust for Railroad Preservation (MSTRP) members visited the Lima locomotive erecting hall in the spring of 1990. At that time, Nickel Plate Berkshire 765 was undergoing maintenance and restoration in the place of its birth. Before moving to New Haven (Fort Wayne), Indiana, the volunteer organization that preserved NKP 765 used the old Lima erecting halls as a home for their restoration project. (Courtesy Steam Railroading Institute Collection.)

The empty former Shay erecting bay of the Lima Locomotive Works is shown in this photograph from 1990. Steam locomotives continued to be built after Lima's merger with General Machinery of Hamilton, Ohio, in 1947. Fittingly, Nickel Plate Road Berkshire No. 779 was the final steam locomotive Lima produced, rolling out in 1949. For the next few years, Lima-Hamilton built 174 diesel locomotives and then merged with Baldwin Locomotive Works in 1951. Baldwin-Lima-Hamilton ended all locomotive production at Lima in 1956. Clark Equipment Company bought the former Lima facility and continued to build construction equipment and cranes until 1980, when all production ceased and the plant was closed. (Courtesy Steam Railroading Institute Collection.)

Like most of its offspring, the mighty Lima shop complex was eventually made obsolete by newer factories and more modern technology. A tax proposal attempted to save a few portions of the buildings on the abandoned site, but, after the levy failed at the polls, the buildings of the Lima Locomotive Works were leveled in 1998 and the site was cleared and prepared for other uses. As this 2014 view shows, nothing remains of the once-great facility, and the former site remains mostly empty. Fortunately, due to the efforts of several former Lima employees, many of the photographs and engineering documents remain safely housed in either the Allen County Historical Museum, in Lima, Ohio, or the California State Railroad Museum, in Sacramento, California. (Courtesy T.J. Gaffney collection.)

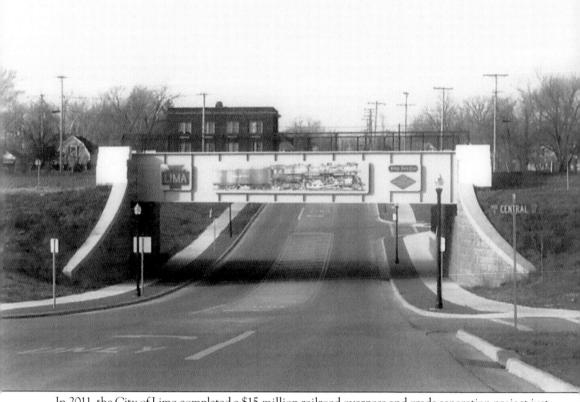

In 2011, the City of Lima completed a $15-million railroad overpass and grade separation project just north of the now-vacant site of the Lima locomotive complex. The bridge carries the tracks of the Norfolk Southern (formerly Nickel Plate) and CSX (formerly Baltimore & Ohio) lines across Vine Street. The city also included this very nice tribute to the heritage of Lima Locomotive, with this image of a 2-8-4 Berkshire, the Nickel Plate Railroad herald, and the diamond-shaped builder's plate used by Lima Locomotive gracing the exterior of the bridge. (Courtesy T.J. Gaffney collection.)

Two

HAULING THE ARSENAL
OF DEMOCRACY

By 1937, the Pere Marquette locomotive fleet was getting tired. No new locomotives had arrived on the property in 10 years, and the Great Depression had not been kind to the "Poor Marquette." America's railroad traffic tumbled by 25 percent or more during the 1930s, falling from a high of 455 billion ton-miles in 1929 to 339 billion ton-miles in 1939. By contrast, today's modern, more productive railroads move 1.5 trillion ton-miles of freight each year, using half the equipment and one-tenth the number of employees that existed in 1935. Pere Marquette employees were known for keeping their charges well maintained, and a few hand-me-down pieces had been acquired from other railroads, but the time had come for some new, more modern power. The Pere Marquette was controlled by the Van Sweringen brothers of Cleveland and had participated with other Van Sweringen roads in the Advisory Mechanical Committee specifications for steam locomotives with a 2-8-4 wheel arrangement (two pilot wheels, eight driving wheels, and four wheels supporting the firebox and cab). So, in the spring of 1937, an order was placed with Lima for 15 of the new locomotives.

The arrival of the first Berkshire-type locomotives, on September 13, 1937, must have come as a welcome relief to everyone involved with the Pere Marquette. First introduced by Lima in 1925 and named for the mountains in western Massachusetts that saw their first successful use, they were larger, faster, and more powerful than any other locomotive the railroad had ever owned. They immediately went into freight service along the PM's main trunk lines from Chicago through Grand Rapids to Detroit, and between Saginaw and Toledo. Weight restrictions prevented them from traveling north of Saginaw. The war years saw a huge boom in traffic, but, soon after the end of World War II, diesels began to arrive on the property and the days of steam were numbered. Although they had been expected to last for 50 years, the 39 locomotives of the three Pere Marquette Berkshire classes were retired after only 7–14 years of service. Most spent the 1950s forlorn and rusting in isolated yards in western Michigan, waiting for the inevitable scrapper's torch.

But this chapter is about happier times, and the following pages show images of PM 1225 and all her sisters doing what they were meant to do: pulling long freight trains on passenger-train schedules.

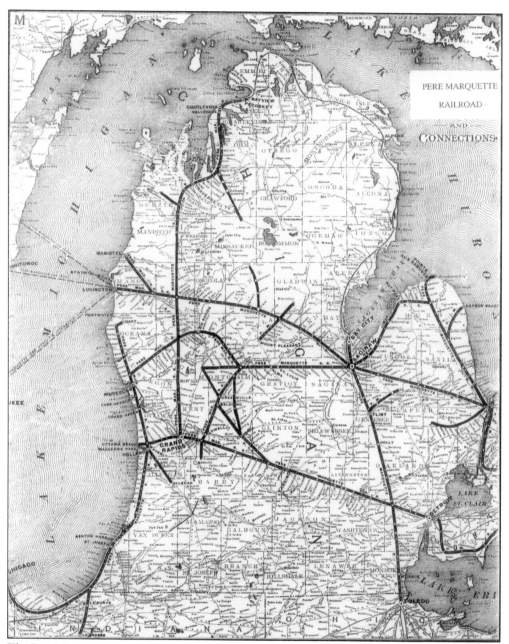

The Pere Marquette Railroad was formed on January 1, 1900, when the Chicago & West Michigan, the Detroit, Grand Rapids & Western, and the Flint & Pere Marquette merged to form the Pere Marquette. The three smaller lines were themselves the products of mergers of even smaller lines, dating to the mid-1800s. Similar to airlines or automotive manufacturers today, railroads have always sought out merger partners in an effort to increase efficiencies and achieve greater economies of scale. The Pere Marquette would be absorbed into the Chesapeake & Ohio system in 1947. (Courtesy Dean Pyers collection.)

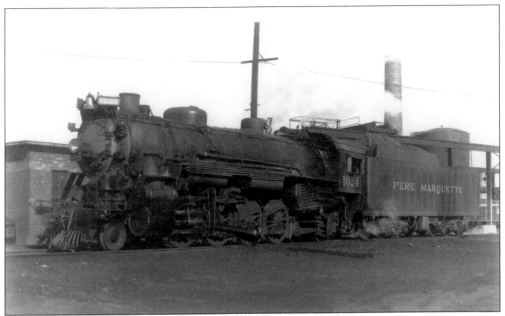

Before the Berkshire locomotives went to work in 1937, the fastest and most powerful locomotives owned by the Pere Marquette were the 2-8-2 Mikado and 2-10-2 Santa Fe types. These locomotives pulled the priority freight trains across the main lines of the system, usually Chicago to Detroit or Saginaw to Toledo. Once the 2-8-4 Berkshires took over those duties, these engines were moved down to less important freight or branch-line service. Here, Mikado 1024 is seen in Wyoming Yard, outside Grand Rapids, Michigan, on September 19, 1944. PM 1024 was one of the many standardized light Mikados constructed and distributed by the United States Railway Administration during World War I. She was built by Lima in 1919 for the Indiana Harbor Belt and was assigned to the PM in 1920. (Courtesy T.J. Gaffney collection.)

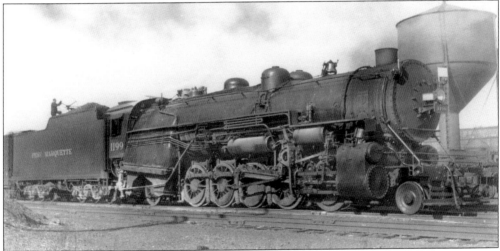

Pere Marquette 2-10-2 1199 is seen in the Plymouth, Michigan, yard in May 1938. PM 1199 and her sister 1198 were also hand-me-downs that came to the PM during the Depression, having been built by Baldwin for the Lehigh Valley in 1919, sent to the Hocking Valley, and then purchased by the PM in 1930. They lasted until 1948, when they were finally retired and scrapped. (Courtesy T.J. Gaffney collection.)

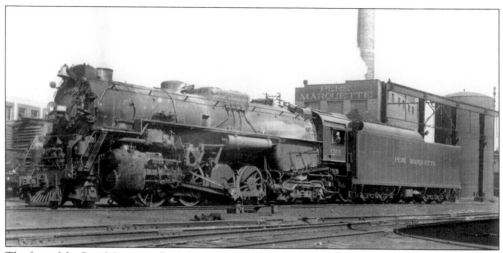

The first of the Pere Marquette Berkshires, No. 1201, was a few years old by the time this photograph was taken in Wyoming Yard on August 20, 1940. Wyoming is a suburb of Grand Rapids, just south of downtown. One of the signature structures in the yard, the powerhouse with the smokestack and company name, will be seen in many photographs. (H. Walhout photograph; courtesy PMHS Collection.)

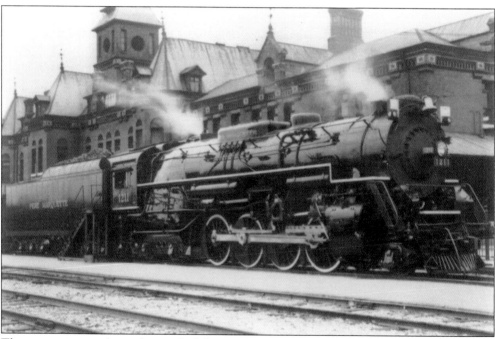

The company was obviously proud of their new power, as evidenced by this photograph from September 1937 at the Potter Street station in Saginaw. PM 1211 was brand-new, and, with stairs leading up to the cab, it was being prepared for display on this day. The photograph was taken by L.M. Brodbeck of Lake Odessa, Michigan, and appeared in *Trains* magazine in August 1941, in an article about overnight express freight service on the Pere Marquette. (Courtesy Art Lamport Collection, PMHS.)

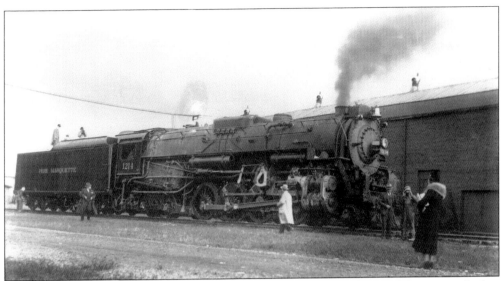

While 1201 through 1211 were already delivered and working for the Pere Marquette, the last of the 15 locomotives in the N series of Berkshires were still under construction in Lima. On Sunday, October 10, 1937, Lima hosted a gathering of 1,000 amateur photographers and model locomotive builders who chartered trains from Chicago and Detroit to visit the locomotive works. PM 1214 was fresh out of the erecting hall and scheduled to be delivered to the railroad the next day, so it was placed on display. Sections of the sheet metal jacketing covering the feed-water system and driving cylinders were removed to give the visitors an up-close look at how those mechanisms work, and the Baker valve gear also seemed to be highlighted with brighter paint. (E. Elliot photograph; courtesy H.J. Walhout Collection, PMHS.)

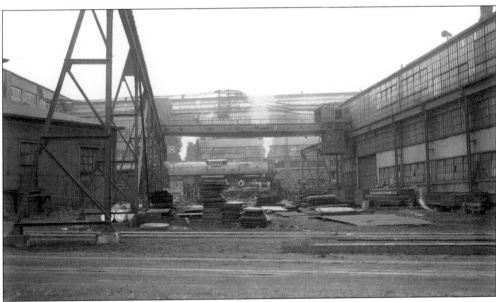

On the same day, 1214 is seen next to Building 10, the pattern shop. One of the passengers on the excursion train ventured deep into the complex to capture this unique image looking through the shop buildings. (Courtesy William and Mike Raia collection, via William Ranke.)

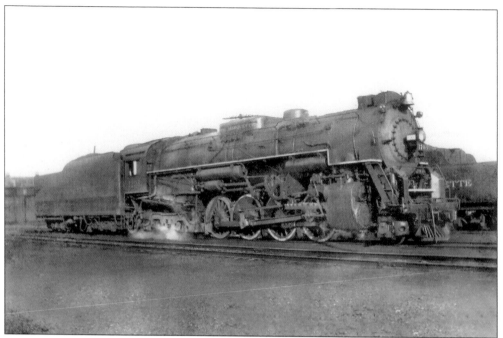

Showing some road grime after just one year in service, PM 1203 rests outside the roundhouse at Ottawa Yard in 1938. Ottawa Yard was the PM's facility servicing Toledo, although it was not in Toledo, it was a few miles north of the border in Erie, Michigan. PM road trains would terminate in Ottawa, sort cars into blocks for interchange with the many other railroads radiating out of Toledo, and run transfer trains a few miles to the yards of the other companies in and around Toledo. (John Clark photograph; courtesy Allen County Historical Society.)

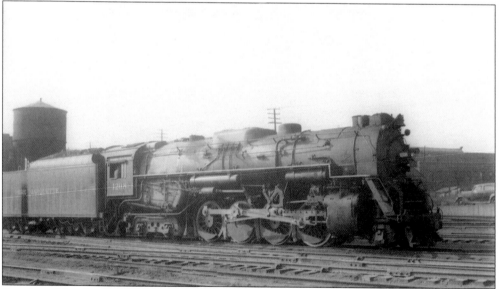

Another of the class-N Berkshires, PM 1208, is seen here on November 5, 1939, in Detroit. Note the smaller size of the lettering on the tender, which was the style used as delivered from Lima. Lima painters were known for doing their number and letter work freehand, with just a few alignment marks in chalk to guide them. (C.W. Jernstrom photograph; courtesy SRI Collection.)

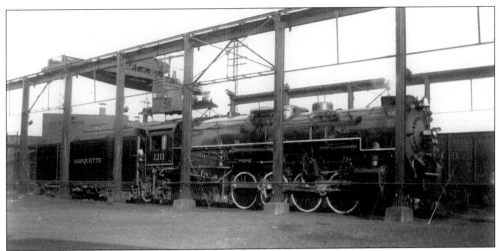

This photograph from November 7, 1937, shows a two-month-old PM 1211 at the ash pits in Wyoming Yard. The overhead outdoor crane structure was used to move ashes from the ash pits and into hopper cars. In an emergency, the crane could also be used to transfer coal from hopper cars directly into locomotive tenders, if the usual coaling towers were unavailable. (W.C. Fitt photograph; courtesy H.J. Walhout Collection, PMHS.)

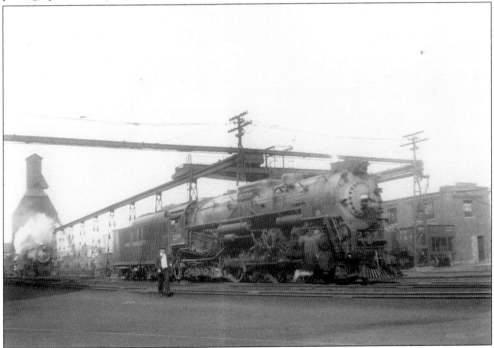

PM 1209 rests at the Twenty-first Street yard in Detroit sometime in the late 1930s. This facility, shared with the Pennsylvania and Wabash Railroads, was at the throat of the overpass that accessed Fort Street Union Station. Due to their weight, the PM 1200s could not travel on this line, unlike the Pennsylvania Railroad K4 4-6-2 sitting under the coal dock on the adjacent track. The large overhead outdoor metal framework is likely a Northern Engineering Works traversing crane, which had a bucket that could both load coal and unload ash. (Courtesy T.J. Gaffney collection.)

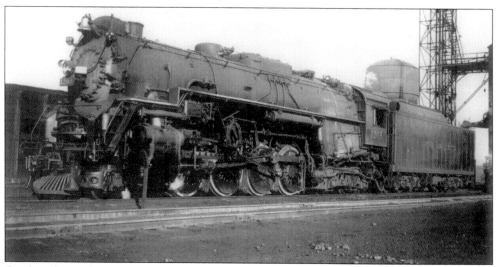

On the other end of the system, Pere Marquette 1205 waits for its next assignment in the Clearing Yard in Chicago. Although almost two years old, she still sports white driving wheels and the smaller tender lettering in this January 10, 1939, photograph. (Merle Anderson photograph; courtesy William and Mike Raia collection.)

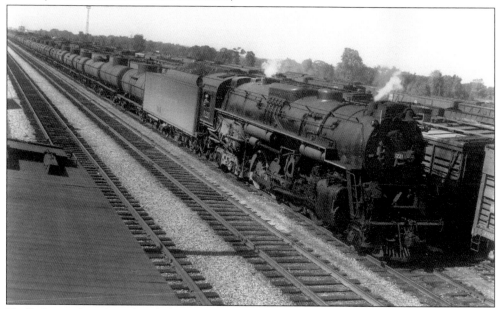

Traffic boomed on the railroads during World War II, but there are not many pictures that show it. Wartime photography restrictions, large numbers of men in military service, and factories running maximum overtime all seem to have limited photography during that era. This photograph of PM 1221 arriving in Wyoming Yard with an oil train in September 1943 appeared in the 1943 Pere Marquette Annual Report. The report mentions that 99,224 tank cars carrying 10,000 gallons of oil each had been moved by the PM to help relieve oil shortages on the Eastern seaboard and for our armed forces overseas. Not mentioned in the report was the fact that one of the causes for this boom in traffic was the danger posed by German submarines lurking off the coast, forcing oil out of coastal freighters and onto the railroads. (PM official photograph; courtesy C&OHS Collection.)

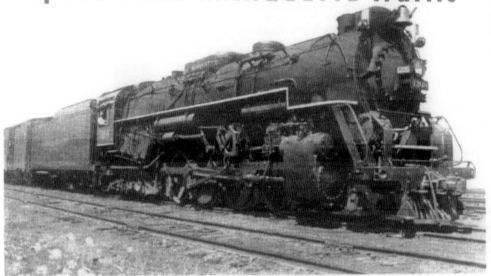

39 LIMA-BUILT 2-8-4 STEAM LOCOMOTIVES
speed PERE MARQUETTE traffic

To meet steadily increasing demands for more rapid movement of freight traffic, Pere Marquette has continued to add to its fleet of Lima-built 2-8-4s, so that today thirty-nine of these modern steam locomotives are speeding the freight service on its lines.

LIMA LOCOMOTIVE WORKS INCORPORATED, LIMA, OHIO

Locomotive manufacturers and the railroads alike trumpeted their achievements in the industry press whenever new locomotives went into service or when new orders were placed, hoping to attract additional business. This advertisement from Lima was placed in *Railway Age* magazine. Shown in the May 1946 edition, it allowed Lima to remind the readers that a total of 39 high-speed 2-8-4 Berkshires were now roaming the Pere Marquette rails, speeding freight to its final destination. (Courtesy Dean Pyers collection.)

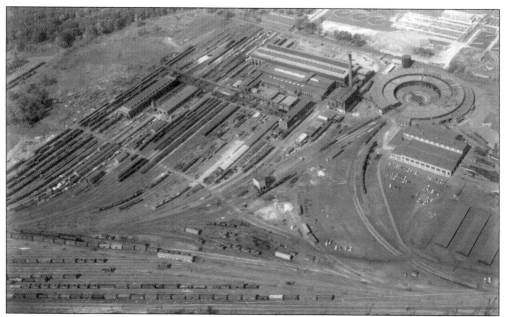

In addition to the heavy manufacturing facilities that created them, steam locomotives required huge railroad shop complexes to maintain them. The Pere Marquette's "citadel of steam" was in the Wyoming Yard near Grand Rapids, Michigan, shown here in an aerial view. Composed of a full-circle roundhouse for daily cleaning and maintenance tasks, car shops, and a major backshop area for heavy locomotive repairs and rebuilding, Wyoming was the home base for the Berkshire-type locomotives and many other PM equipment classes. (Courtesy C&OHS Collection.)

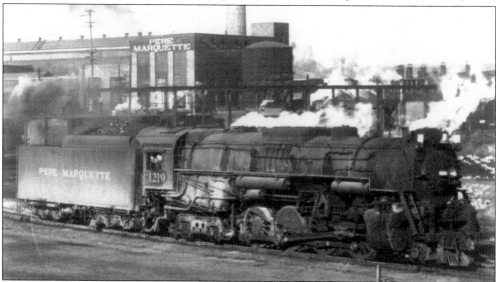

PM 1219 is shown in the Wyoming Yard in the early 1940s. Backshop towns were typically not in the major city endpoints served by railroads, like Detroit, Chicago, and New York. These cities would have large classification yards and significant roundhouses, but the heavy maintenance was often done at an intermediate point such as Grand Rapids, Jackson, Battle Creek, or Owosso. These smaller towns were located at the junction of two division points of their railroad, which were typically 100 miles in length. (Courtesy Art Lamport Collection, PMHS.)

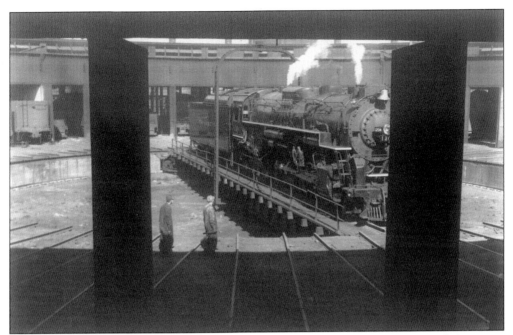

Turntables and roundhouses were efficient uses of space in a railroad yard and provided a means to turn the locomotives around without acquiring the land required to build a wye. A company photographer framed 1204 on the turntable at Wyoming while looking out through the doors of the roundhouse bays in September 1943. (C&O official photograph; courtesy PMHS Collection.)

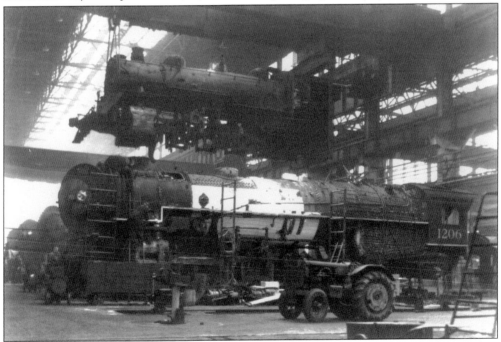

Inside the Wyoming backshop, the work was just as heavy, dirty, and noisy as it had been when the locomotives were being built in Lima. A high-capacity overhead crane moves a locomotive's boiler, cab, and frame over PM Berkshire 1206. (Courtesy Art Lamport Collection, PMHS.)

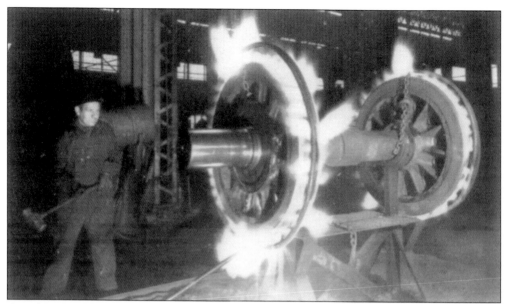

A real "ring of fire" is used to heat the removable steel tires from the locomotive wheels. The tire ring could be replaced as it wore out, saving the expense of casting a completely new wheel. In this photograph, a mechanic prepares to hammer the hot tire rings off the axle assembly of a PM Berkshire locomotive. A similar process in reverse will be used to place a new tire on the wheel. Once the new tire cooled and shrank, it was attached hard and fast to the wheel, with no fasteners or welding rods necessary. (Courtesy Brian Bluekamp collection.)

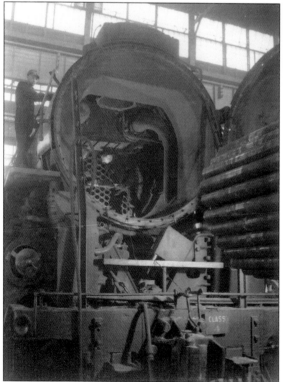

A Berkshire, possibly 1207, undergoes a class-4 rebuilding in the Wyoming backshop in September 1943. The boilermaker inside the smokebox prepares to remove the flues that pass through the boiler. A stack of new tubes awaits their turn to go into the boiler once the removal is done. Similar scenes can still be seen with PM 1225, as all of the tubes and flues must be removed and replaced in its boiler every 15 years. (C&O official photograph; courtesy C&OHS Collection.)

Coal in, cinders out—such is the circle of life for a steam locomotive. PM 1217 is framed by the impressive coaling tower in the Wyoming Yard in this official company photograph from September 1946. Hopper cars of coal would be spotted over an underground dumping chamber, where an elevator takes the coal to the top of the coaling tower. Locomotives would then pull under the tower, lower the coal chutes, and fill up their tender. (C&O official photograph; courtesy C&OHS Collection.)

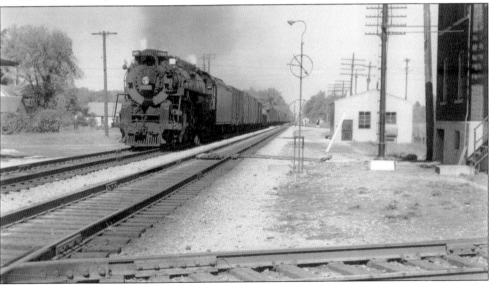

An extensive network of manned towers, sidings, crossings, signals, and telegraph systems also lined the tracks. Here, PM 1221 passes an interlocking tower at Carleton, Michigan, in 1949, with the manual train order stand centered in the photograph. Tower operators would receive instructions via telegraph or telephone, type or write the orders on paper, and attach copies using string across Y-shaped sticks placed into the upper and lower hoops. The engineer would grab the orders from the upper hoop as he passed by at speed, and the conductor would take the orders from the lower rung as the caboose passed by. This tower still stands in Carleton today. (Bob Lorenz photograph; courtesy SRI Collection.)

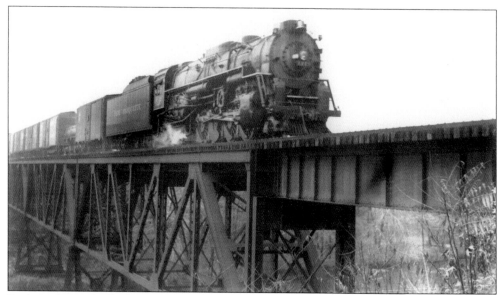

Bridges often make for dramatic settings for railroad photography, and Berkshire 1218 is captured crossing one of them. In this photograph, 1218 crosses the Walled Lake branch of the Rouge River near Novi, Michigan. A bridge similar to the Novi Bridge also stands over the Thornapple River near Grand Ledge, Michigan, and is another favorite spot for photographers. (Courtesy Brian Bluekamp collection.)

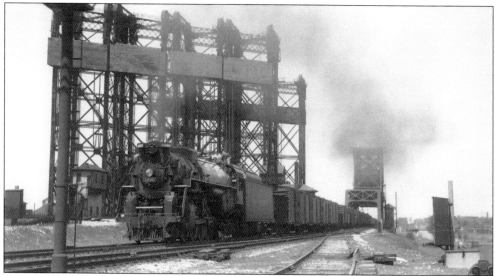

In another impressive photograph backdrop, PM 1231 crosses the Calumet River as it departs Chicago on the Baltimore & Ohio's Chicago Terminal line. The B&OCT bridge was adjacent to the lift bridges for the New York Central and Pennsylvania Railroads. Note the derailing switch in the lower right corner of the photograph, which would prevent trains from entering the area if the bridge was up and also prevent collisions on the bridge. A B&O color-position signal light is seen on the left. Today, the Chicago Skyway (Interstate 90) crosses the Calumet just to the east (right) of this photograph. The B&OCT bridge is dismantled, while three of the four Waddell & Harrington vertical lift bridges remain standing, although only one is still in use. (Unknown photographer (possibly Paul Ellenbuger); courtesy William and Mike Raia collection.)

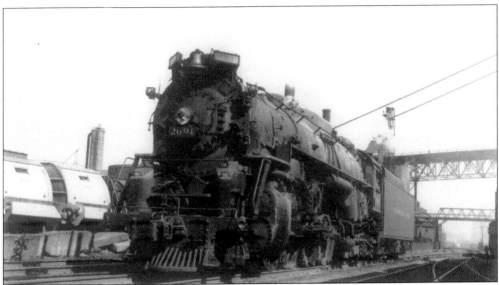

Photographers have their favorite spots, and, in researching these old photographs, it seems that it would be possible to find an image of almost every PM Berkshire posing in Detroit's Twenty-first Street yard, with the Ambassador Bridge in the background. The yard, along the Detroit River, serviced the passenger trains leaving Fort Street Union Depot, industries in Detroit, and a ferryboat dock that moved freight cars across to Canada, a practice that continued into the 2000s. The N-class 2691 (former PM 1207) is seen with the Ambassador Bridge in the background on October 10, 1948. (Arthur B. Johnson photograph; courtesy C&OHS Collection.)

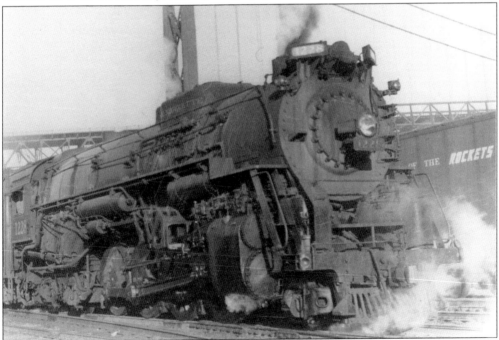

The lead unit of the third and final group of Pere Marquette Berkshires, class N-2 No. 1228, takes its turn under the bridge in later years, with a Rock Island coal hopper in the background. (Courtesy T.J. Gaffney collection.)

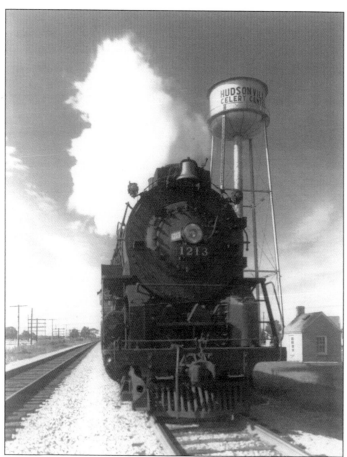

Water towers for cities or industries that appear in vintage photographs often come in handy for determining where the photograph was taken. Here, PM 1213 waits in a siding with a manifest freight in Hudsonville, "the Celery Center of Michigan," in September 1945. (C&O official photograph; courtesy Art Million Collection, PMHS.)

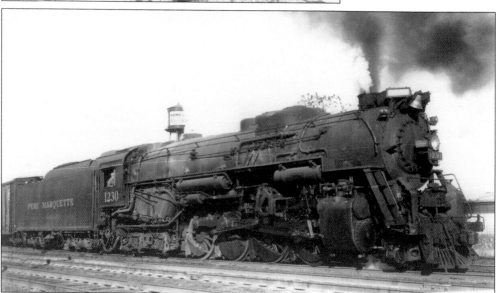

On October 21, 1950, PM 1230 is seen passing a factory that is proud to be the "Home of Kool-Aid" in Chicago. (Courtesy William and Mike Raia collection.)

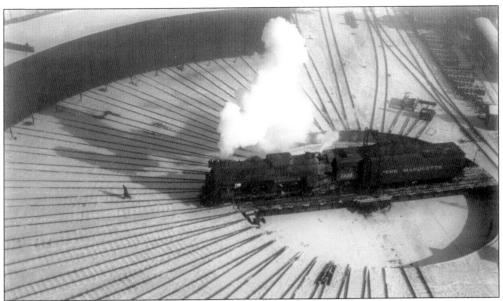

Winter in Michigan provided great contrasts in the era of black-and-white photography, attracting not only railfans but also professional photographers. Lionel J. Tidridge of Windsor, Ontario, was not particularly interested in railroads, but, as a professional photographer, he knew the composition of a good photograph when he saw it. This photograph of 1222 on Fort Street's turntable during a cold winter's day was taken from the Ambassador Bridge and won a prize in *Popular Photography* magazine. It also appeared in the August 1951 issue of *Railroad* magazine. (Lionel Tidridge photograph; courtesy Dean Pyers collection.)

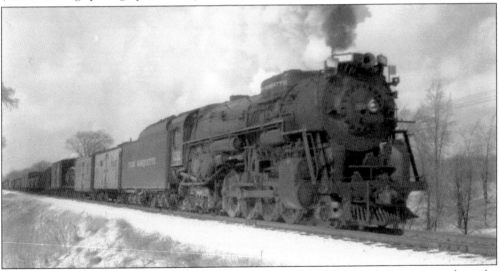

Originally from West Virginia, Walter Wilk participated in the Great Migration north to the promise of prosperity in Detroit's automotive plants. A photographer and railfan all his life, Wilk served as an Army Air Corps reconnaissance photographer during World War II and later joined friends on many railfan trips to Midwestern and Eastern states. On February 14, 1948, Wilk captured PM 1232 with 85 cars near Plymouth. Note the stunning cloud of steam rising from the stack, and the Santa Fe Railroad ice refrigerator car advertising "The Scout" passenger service immediately behind the tender. (Walter Wilk photograph; courtesy John Kucharski collection.)

Not everything goes perfectly on the railroad, as these photographs demonstrate. PM 1202 with Train #40 and 1218 leading Train #59 abruptly came together in Waverly, Michigan, at 2:25 am on June 30, 1943. Significant damage was done to the running boards and front appliances of both locomotives, which cost $16,000 to repair. (Courtesy C&OHS Collection.)

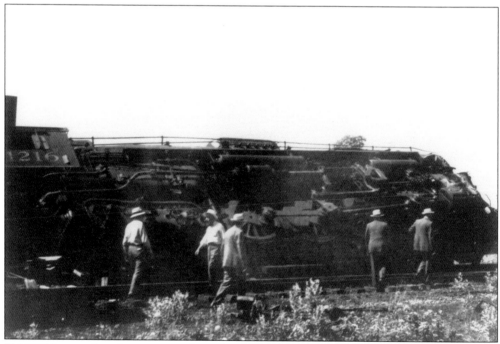

PM 1216 is seen tipped over on its side in this undated photograph from a location near Detroit. (Courtesy H.J. Walhout Collection, PMHS.)

The last of the Pere Marquette Berkshires, class N-2 1239, rests at the Detroit coal dock on August 7, 1948. (Courtesy William and Mike Raia collection.)

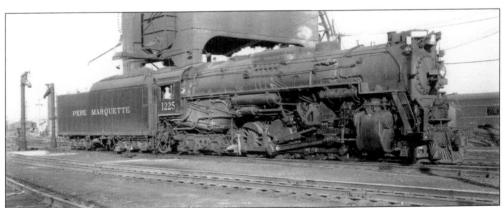

Observant readers may have noticed by now that there have been no photographs of PM 1225 in service. Fortunately, over the 40 years that the student and volunteer restoration groups have existed, a number of 1225 photographs have been donated to the group. Here are a few photographs of this favorite "Berk" at work, beginning with this one of 1225 at the same Detroit coal dock with water columns in the background. (Courtesy William and Mike Raia collection.)

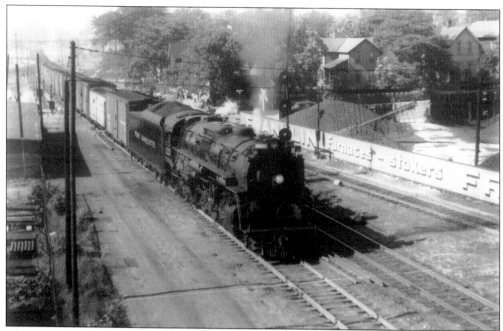

Clearing the Wyoming Yard limits and heading east towards Lansing, PM 1225 crosses Pleasant Street in Grand Rapids. A supplier of Franklin Furnaces and other heating equipment advertises its products on the fence to the right. Much of this area has now been changed by the construction of the Route 131 expressway. (Frank Anthony photograph; courtesy R. VandeVusse collection.)

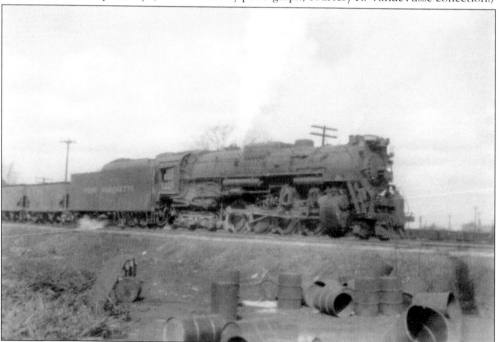

With more of that ubiquitous trackside clutter of empty barrels, scrap metal, and all the other things Americans keep in their backyards, PM 1225 works near Plymouth, Michigan, in 1948. (George Kusterer photograph; courtesy David Jones Collection, SRI.)

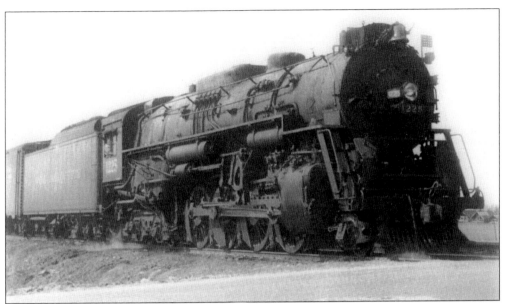

PM 1225 waits at Trowbridge Road in East Lansing, Michigan, in the early 1940s. The engineer leans out of the cab, presumably waiting on a signal, in the traditional pose. While 1225 has a number of fans and supporters today, she was not a favorite of the crews in the 1940s. When retired PM engineer Sam Chidester joined the MSU Railroad Club in the early 1970s, he sent a note to the club mentioning that, while he was happy to hear that 1225 would run again, he felt it rode a little rougher than the other Pere Marquette Berkshires. (Courtesy Brian Bluekamp collection.)

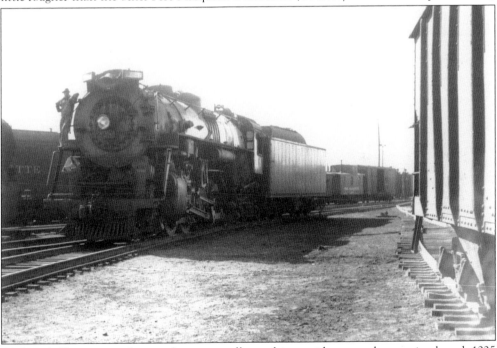

With its bell ringing and a switchman casually catching a ride up on the running board, 1225 glides through Wyoming Yard in this undated photograph. (Frank Anthony photograph; courtesy R. VandeVusse collection.)

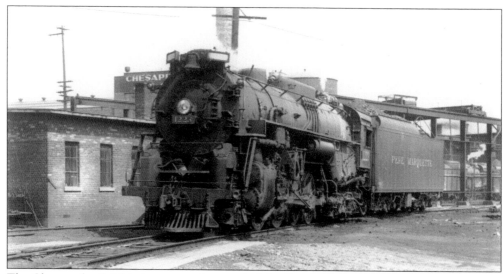

The Chesapeake & Ohio has assumed control of the Pere Marquette, as evidenced by the high number boards and the relettering of the Wyoming powerhouse. PM 1223 passes through the yard, with the ash pit tracks and overhead crane in the background. For whatever reason, in-service shots of 1223 are difficult to find, but this locomotive is the only other PM Berkshire that was preserved. Donated by the C&O to the City of Detroit in 1960 after a fundraising campaign by Detroit public school children, 1223 was placed behind the grandstands at the Michigan State Fairgrounds. The locomotive is now in Grand Haven, Michigan. (C&O official photograph; courtesy C&OHS Collection.)

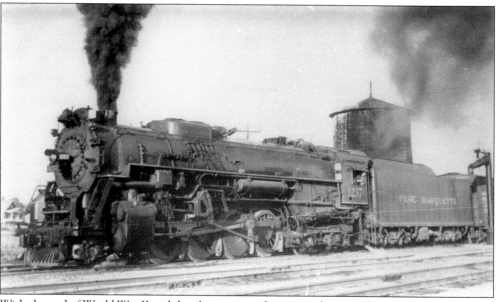

With the end of World War II and the elimination of wartime photography restrictions, returning veterans and railfans alike went trackside en masse with "Speed Graphic" cameras in hand to capture the last few years of steam power. Here, PM 1237, an N-2–class locomotive and one of the last delivered, rests near the water tower at Ensel Yard in Lansing, Michigan. The photographer, Don Etter, was the uncle of current SRI volunteer Fred Stevens. (Don Etter photograph; courtesy PMHS Collection.)

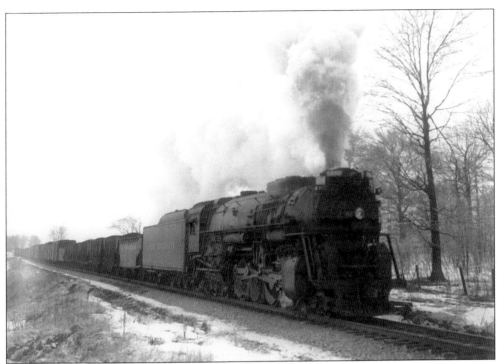

PM 1236 approaches Plymouth as it leads a train between Grand Rapids and Toledo in another photograph taken by Walter Wilk, this one on February 15, 1948. (Walter Wilk photograph; courtesy John Kucharski collection.)

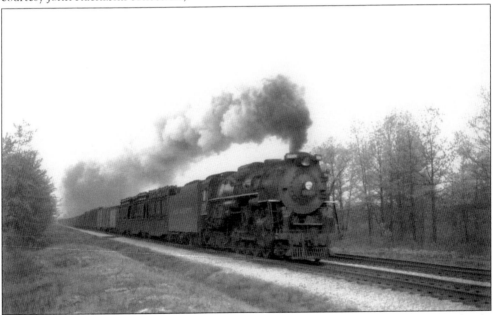

PM 1219 runs at an estimated 70 miles per hour east of Plymouth on May 2, 1949. The 65 freight cars in the consist would be mostly auto parts, as evidenced by the gondolas at the front of the train carrying auto frames, with additional frame loads farther back. (Walter Wilk photograph; courtesy John Kucharski collection.)

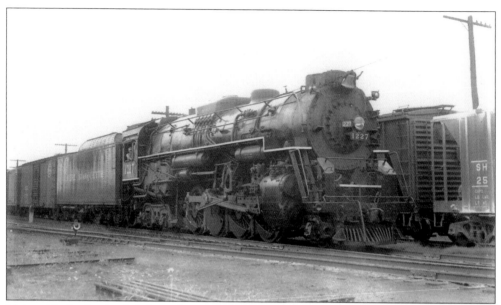

Major cities had union belt lines that encircled the city and were owned in shares by a variety of the major carriers that served that city. The Belt Railway of Chicago was formed in 1882, and it is still owned by the six major systems serving Chicago. The Pere Marquette would drop freight off at the Belt's Clearing Yard, located on the south side of Chicago near Bedford Park. PM 1227 is shown here at Stoney Island Avenue on August 31, 1947. (Courtesy Richard Cook Collection, Allen County Historical Society.)

Another major yard in the Detroit area was the Rougemere complex, servicing Ford Motor Company's River Rouge plant in Dearborn, Michigan. PM 1235 is seen here in 1950, with the Rouge Power Plant and a Ford railway tank car in the background. (Courtesy H.J. Walhout Collection, PMHS.)

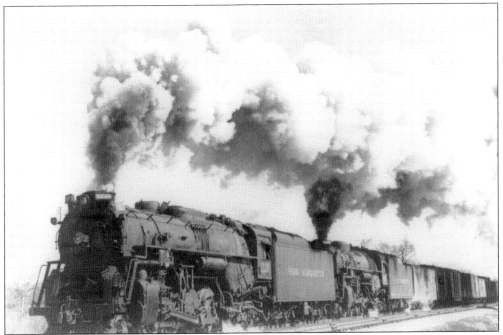

Sometimes, 3,000 horsepower just is not enough, so even the Berkshires were forced to double-head. PM 1220 and 1229 work together to move a train near Lansing on their way from Detroit to Grand Rapids on November 4, 1950. (Arthur B. Johnson photograph; courtesy Brian Bluekamp collection.)

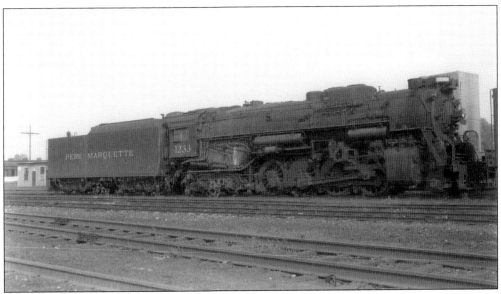

Photographs of the Pere Marquette Berkshires are not evenly distributed, as some just seemed to work in obscurity and avoided the photographer's lens. The only known photographs of 1233 are either in the scrap line or this undated photograph, which shows her still in service. The repositioned sand dome of the N-2 class is clearly visible in this photograph. (Courtesy C&OHS Collection.)

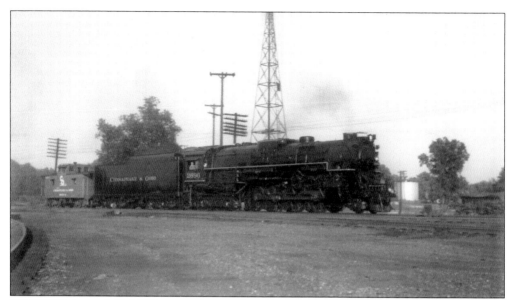

C&O 2696, formerly PM 1212, is seen here with a caboose. After the Chesapeake & Ohio acquired the Pere Marquette in 1947, plans were made to renumber the 1200-series engines and repaint them as C&O engines. Only the N-series locomotives, the first 15 delivered in 1937, were ever renumbered, however. (Courtesy Art Million Collection, PMHS.)

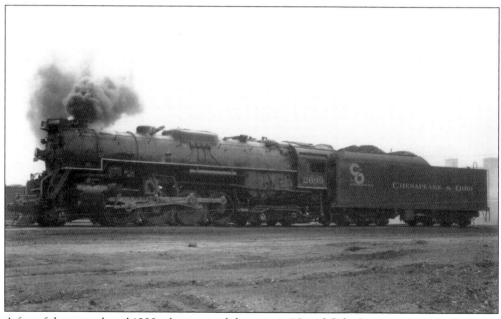

A few of the renumbered 1200s also received the artistic "C and O for Progress" herald, which was appearing on a wide variety of C&O equipment at the time. Don Etter caught this photograph of C&O 2699, formerly known as PM 1215, in Wyoming Yard. (Don Etter photograph; courtesy Art Million Collection, PMHS.)

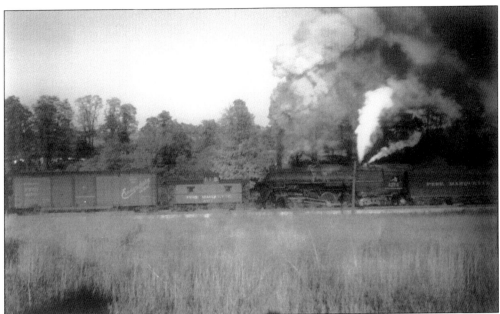

One of the last uses for steam locomotives was in helper service pushing trains locally over sections of track that went up hills or longer grades. This would allow a railroad to avoid adding additional power at the front of the train for the entire trip. One of the only helper districts on the Pere Marquette system was New Richmond Hill on the west side of the state. PM 1214 works here in helper service in the fall of 1948. (Photograph by "J.V.O"; Andy Gras Collection, PMHS.)

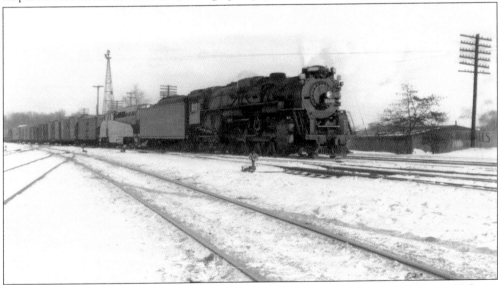

A few diesel-powered switch engines were ordered by the Pere Marquette as early as 1937, but it was the arrival of the oddly styled BL-2s in 1948 and the popular GP-7s in 1950 that signaled the end of steam on the Pere Marquette. Requiring far less maintenance and generally more efficient than a steam locomotive, the Michigan region of the C&O lines completed the conversion to diesel power fairly quickly. All steam was retired by the end of 1951. In this photograph, C&O 2688, formerly PM 1204, leads one of the BL-2 diesels and a train through what is believed to be Wyoming Yard. (George Leisgang photograph; courtesy PMHS Collection.)

Frank Anthony was fortunate enough to receive a ride in the cab of a new E7 passenger locomotive between Grand Rapids and Lansing, and he caught this photograph of old power meeting new, as the freight train pulled by 1211 meets the passenger train. (Frank Anthony photograph; courtesy R. VandeVusse collection.)

Some of the old-timers gather as 1224 undergoes one of its last overhauls in the Wyoming shops in 1951. (Courtesy Art Lamport Collection, PMHS.)

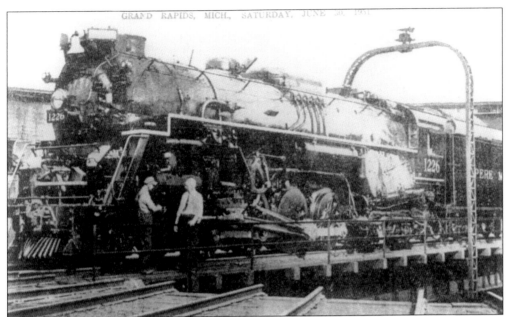

The *Grand Rapids Herald* ran this story, "A Final Paint Job for the Last Lap," on Saturday, June 30, 1951. It was already known that, by the end of the year, the "out-moded" locomotive would be retired, but the PM kept them in good condition right up to the end. C&O shop crews in other areas of the country that received PM power often commented on how well the locomotives were maintained. G.W. Fuller (left), shop superintendent, and Al Bochniak, locomotive painter, join 1226 in this photograph. According to the logbook of Waverly Yard hostler Charlie Veldheer, 1226 became the last Berkshire to run in service for the Pere Marquette, leaving Waverly for Grand Rapids on November 25, 1951. (*Grand Rapids Herald* photograph; courtesy PMHS Collection.)

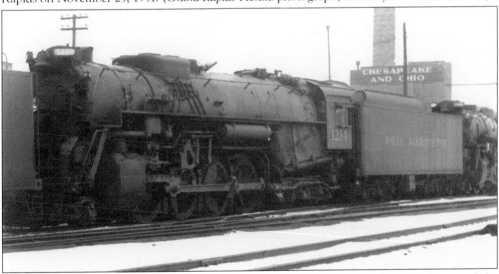

Once retired, the Berkshires were collected and placed into storage tracks in yards around the system. Many could not be scrapped immediately, as loans and equipment trusts had been set up for 15 years when they were purchased, and they could not be disposed of until the late 1950s. Here, PM 1234 sits in a long line of locomotives in Wyoming Yard, date unknown. (Courtesy Art Lamport Collection, PMHS.)

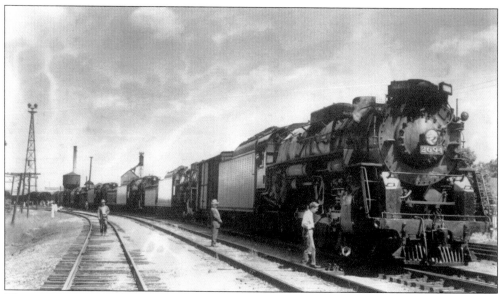

There was only one reason for this train to be assembled in July 1950, and that was to transport a string of surplus locomotives from the Pere Marquette district to other parts of the C&O system. C&O 2694, the former PM 1210, prepares to depart a yard believed to be Saginaw. Art Million's *Pere Marquette Power* notes that five Berkshires, the former Nos. 1210–1214, were dispatched to the Chesapeake District to work between Columbus, Ohio, and Richmond, Virginia. Since 1210 is leading this train and five Berkshires are visible, it is probable that this is the transfer train that moved these locomotives to coal service in Ohio, Kentucky, and Virginia, although Million's book lists the move as occurring in March 1951. In April 1952, they were followed by Nos. 1209, 1218, 1222, 1226, 1230, and 1235. All of the locomotives that saw additional service were considered to be the best mechanical locomotives of their classes. (Courtesy Art Million Collection, PMHS.)

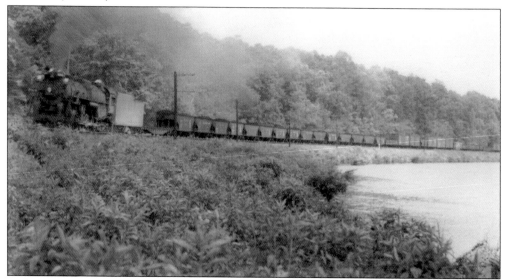

Still carrying its original number and Pere Marquette lettering, No. 1218 pulls a freight train at milepost six along the James River just outside of Richmond, Virginia, on June 1, 1952. (Courtesy C&OHS Collection.)

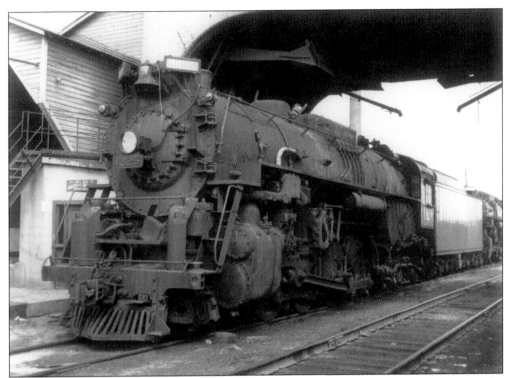

PM 1225 did not see extended service, and so joined 28 of her sisters in the scrap lines by January 1, 1952. Here, 1225 rests under the coaling tower in Grand Rapids in 1954. (Courtesy SRI Collection.)

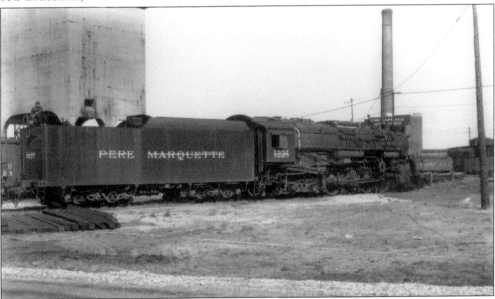

Locomotives that were taken out of service have their numbers and lettering crossed out, as seen in this photograph from 1955. The familiar structures of Wyoming Yard appear in the background, and a souvenir hunter appears to be working on the tender lamp. (Andy Gras Photograph; courtesy C&OHS Collection.)

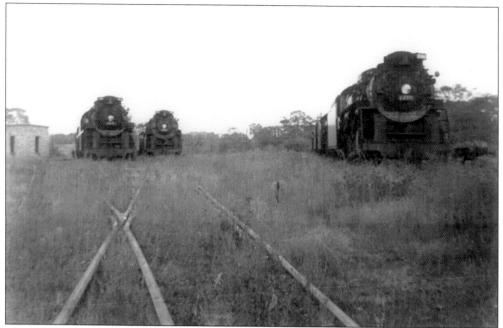

Scrap lines were bleak, desolate places, with weeds growing up over the tracks and rust forming on the once-powerful locomotives. But a few photographers continued to visit, as evidenced by this photograph taken of 1231, 1221, and 1219 in Holland's Waverly yard in the late 1950s. (Courtesy Brian Bluekamp collection.)

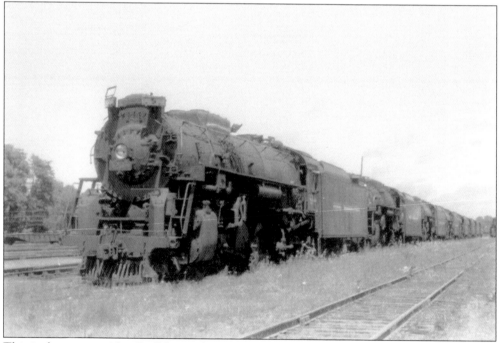

This is the scene in New Buffalo, Michigan, in the mid-1950s. Somewhere in this line of Pere Marquette Berkshires, and behind No. 1238, sits PM 1225, patiently waiting for its next assignment. (Courtesy Brian Bluekamp collection.)

Three

THE SPARTAN LOCOMOTIVE

As the 1950s dawned, the rendezvous of 1225 with the scrapper's torch seemed inevitable. She and her sisters were valued at about $15,000 each as scrap metal, and a post–World War II America was hungry for what that steel could become. The story of how 1225 survived to see another day is one worth telling.

According to Michigan State University Railroad (MSURR) Club member David Jones in his 1987 *Trains* article "The Spartan Locomotive," and stories told to former club president Chuck Julian by Michigan State University (MSU) Museum director Rollin Baker, C&O Railway president Cyrus K. Eaton contacted Forest Akers, the vice president of Dodge's motor division, in 1957. Eaton was disappointed that the relatively new Berkshires were being sent to scrap, and he suggested to Akers, an MSU trustee, that one of the 1200s be given to MSU's engineering department as a teaching tool. While university president John Hannah was not particularly hot on the idea, Forest Akers had given money in trust to the university, and Hannah was not about to argue with one of his biggest donors. So it was that the last engine in line, 1225, was pulled out of the deadline at New Buffalo, gussied up, complete with new "Chesapeake and Ohio" lettering on the tender, and towed to East Lansing. On June 6, 1957, PM 1225 was dedicated and put on display just south of Spartan Stadium. Maintenance was fairly minimal in its outdoor display, but it did receive an aluminum cover for its tender and an occasional paint job when needed, funded by a $600 budget provided by Hannah. Sadly, all the rest of the Berkshires, except 1223, went to scrap by 1962.

After her 1957 dedication, 1225 lay dormant and slowly deteriorated. When someone tried to start a fire in its firebox, MSU reacted by removing all the grates, welding the firebox door half open, and putting a locking steel door on the cab of the engine. In addition, a fence was constructed around it, whose gate was only opened during football weekends for tours to the public. So it remained until a crazy bunch of college kids came together with the notion of getting the old girl running to carry their fellow students to Michigan State away games every year. With the help of a few railroad retirees, a lot of time, hard work, and perseverance, the vision eventually turned into reality. This is their story.

It is June 6, 1957, and three gentlemen discuss the recent gift of 1225 to Michigan State University. Standing from left to right are MSU vice president Thomas Hamilton; Forest Akers, MSU trustee and the man responsible for the donation; and C&O Railway northern region head C.J. Milliken. (Courtesy MSURR Club Collection, SRI.)

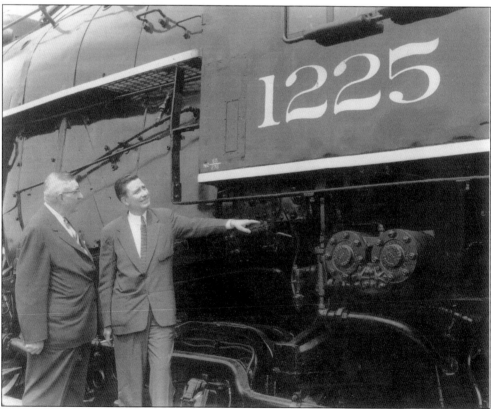

Forest Akers and MSU vice president Thomas Hamilton discuss the 1225, behind them in this 1957 view. Neither of these men could have foreseen the future of this engine or its evolving relationship with the university, let alone the fact that it would ever run again. (Courtesy MSURR Club Collection, SRI.)

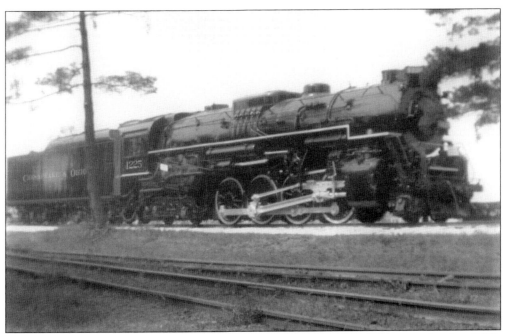

PM 1225 sits on its display site across from MSU's Shaw Lane Power Plant in this late-1950s photograph. In the early 1960s, the university put a fence around the locomotive, due to vandalism issues and concerns over students potentially injuring themselves while climbing on the locomotive. (Courtesy Aaron Farmer collection.)

C&O E7 Diesel 96 leads a 4-H Club excursion passenger train past the displayed PM 1225 2-8-4 locomotive at MSU in East Lansing in June 1965. For many years, MSU's Shaw Lane Power Plant was powered by coal, which was fed by a fairly continuous line of coal cars supplied via a spur from the C&O mainline through the community. It was via this spur that 1225 was delivered. (Courtesy C&OHS Collection.)

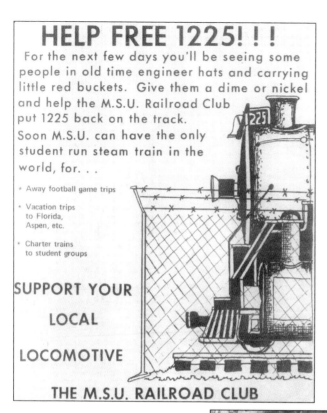

HELP FREE 1225!!!

For the next few days you'll be seeing some people in old time engineer hats and carrying little red buckets. Give them a dime or nickel and help the M.S.U. Railroad Club put 1225 back on the track.

Soon M.S.U. can have the only student run steam train in the world, for. . .

* Away football game trips

* Vacation trips to Florida, Aspen, etc.

* Charter trains to student groups

SUPPORT YOUR

LOCAL

LOCOMOTIVE

THE M.S.U. RAILROAD CLUB

All volunteer organizations face a mammoth challenge in getting people to come out to work. The early days of the MSU Railroad Club were no different. The first promotional campaign was simply printing the numbers "1225" on a yellow sheet of paper and posting it in classrooms across the campus to get people to ask what the number meant. This advertisement appeared in the MSU newspaper to try and do just that. What college student would not be lured in by the idea of taking a steam train ride to Florida or Aspen for spring break? (Courtesy MSURR Club Collection, SRI.)

In 1969, students Chip Rogers (left) and Steve Reeves were earning extra money by giving tours of 1225 on football weekends. In this capacity, they met others who liked railroad equipment, and they eventually decided to form the MSU Railroad Club. After a couple of meetings, another early member, Randy Paquette, thought getting the 1225 running would be a worthy endeavor. Here, Rogers (left) and Reeves hold an engineer's cap as the symbolic start to work on Pere Marquette 1225. Reeves, as the founding member, received membership number 1, which he retains to this day. (Courtesy MSURR Club Collection, SRI.)

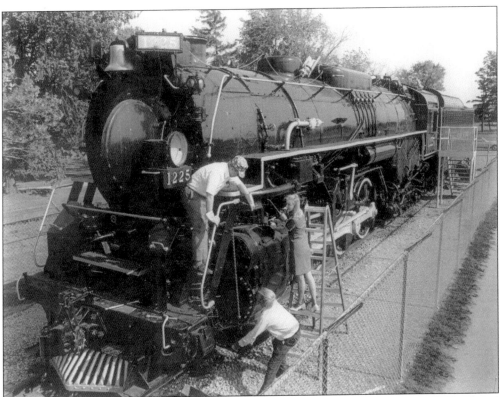

MSU Railroad Club members Steve Reeves (on the steps) and Randy Paquette (under him) and an early volunteer assess the work ahead. This image, originally published in the November 1970 issue of *Railroad Model Craftsmen*, was one of the first times the MSURR Club and its work was noted in a national magazine. It was also published in the January 29, 1971, edition of the Brotherhood of Locomotive Engineer's newsletter. Ironically, at almost the same time, the dean of the Engineering College was quoted in the *Lansing State Journal* saying that a steam locomotive no longer had value as a teaching tool. (John B. Corns photograph; courtesy MSURR Club Collection, SRI.)

On a chilly Football Saturday in East Lansing, and while most alumni and coeds are headed for the game at Spartan Stadium, a group of stragglers surveys the handiwork of an MSU Railroad Club work session. One of 1225's air tanks is lying on the ground alongside her drivers, and several smaller pieces lean against the fence enclosure. Some observers donated a few dollars, while others shouted, "It'll never run!" (Courtesy MSURR Club Collection, SRI.)

Early on, the club realized they needed a place to store parts removed from the locomotive and to house machine tools. In the summer of 1971, Aarne Frobom, Kevin Keefe, and Randy Paquette heard of several baggage cars made surplus due to the recent formation of Amtrak. They traveled to the Grand Trunk Western (GTW) yards in Battle Creek, where they found the 1914-built RPO 9683. The cash-strapped club offered the GTW $500 for the car, and, amazingly, it was accepted. The delivery of the MSU Railroad Club's first official piece of rolling stock came on September 23, 1971. (Courtesy MSURR Club Collection, SRI.)

Aarne Frobom and Jim Sneed lower the Weidike tube cutter out of the new "tool car" during a work session. The car soon became home to more than just tools; it often played the role of warming station during the cold winter months and even served to shelter club members from drifting tear gas during a student demonstration on May 9, 1972. Today, a portion of this car is restored and on display in the National Postal Museum in Washington, DC. The stairs were left behind at a Jefferson Airplane concert at Spartan Stadium on Sunday, May 24, 1970, a show that also featured Chicago, John Sebastian, and Rotary Connection. (Courtesy MSURR Club Collection, SRI.)

MSURR Club members (from left to right) Chuck Julian, Jeff Wells, and Scott Williamson work on reinstalling the turret manifold on the locomotive. A steam locomotive turret is a type of valve manifold, or a pipe fitting with several branches. Each of these branches supplies steam to one of several appliances, and each branch is equipped with a shutoff valve. (Courtesy MSURR Club Collection, SRI.)

Scott Williamson (left) and Andy Kwyer work on the top of the boiler, while Kevin Keefe works in the smokebox in this spring 1971 photograph. Founding member Keefe was the original editor of the club's newsletter. After graduation, he became a newspaper reporter in Niles, Michigan, and he later assumed the role of editor for *Trains* magazine and editorial vice president at Kalmbach Publishing. (Courtesy MSURR Club Collection, SRI.)

In another view, boilermaker Ken Pelton welds new caps on the stay bolts while fellow volunteers Norm Burgess (standing) and Jerry Willson (kneeling) look on. (Courtesy MSURR Club Collection, SRI.)

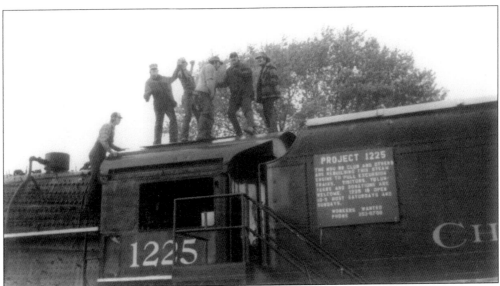

Several volunteers stand on the cab of 1225 to lift and drop a 10-foot piece of rail in an effort to ram the stubborn draw bar pin loose. The draw bar connects the engine to its tender. Not seen are several other volunteers underneath the cab using a puller to try and pull the pin loose. Unfortunately, this did not work; it had to be torched out, and a new pin was made. Note the large plywood sign attached to the tender, noting that "Visitors, volunteers and donations are welcome." From left to right are Steve Zuiderveen, Frank Hubbard, Paul Hubbard, Neil Puetz, Steve Medvik, and David Jones. (Courtesy MSURR Club Collection, SRI.)

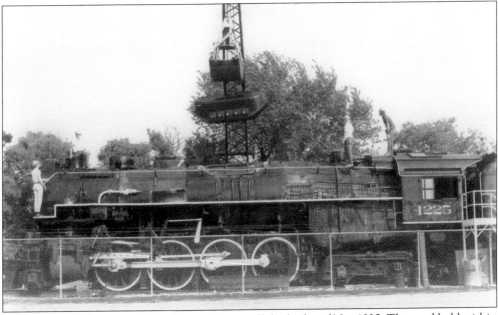

MSU's heating plant crane lifts the sand dome off the boiler of No. 1225. The sand held within it, when applied via the pipes leading from the dome on either side of the boiler, allows the drive wheels of the locomotive to get traction on wet rails in rainy or snowy conditions. From left to right are Andrew Kwyer, Bob Wasko, Randy Paquette, Pete Camps (behind Paquette), and Kevin Keefe. (John B. Corns photograph; courtesy MSURR Club Collection, SRI.)

Volunteers use a crack hammer to test the stay bolt caps of the boiler while another volunteer looks on in this November 5, 1972, view. If the cap over the stay bolt thudded or dented, it had to be chipped off and replaced, a process done by retired C&O boilerman Ken Pelton. From left to right are (on the catwalk) an unidentified volunteer and Jim Sneed; (on top of the boiler) Jeff Wells and Jerry Willson. (John B. Corns photograph; courtesy MSURR Club Collection, SRI.)

One of the keys to Lima's "superpower" concept was the use of superheated steam to generate additional horsepower for the locomotive. A superheater unit converts wet, or "saturated," steam into dry steam by heating it up beyond the vapor point. By drying the steam, the superheater can then generate more thermal energy, allowing for greater efficiency. Saturated steam drops water as soon as it cools. That water does not compress, so if there is water condensing in a cylinder, it can blow the head off when the cylinder reaches full stroke. Roger Scovill carefully cuts the bends out of one of 1225's 54 superheater units, each of which contained three or four sets of pipes. (Courtesy MSURR Club Collection, SRI.)

MSURR Club members Phil Atwater and Jim Sneed turn a Weidike flue cutter on the 1225. The Weidike is an inside pipe cutter and allows the tubes to be cut just past the tube sheet for removal. Two Weidike cutters were purchased in 1973 for $1,100, which was quite a princely sum for a club with dues of $5 per year and rarely more than $3,000 in the bank. The portion remaining in the tube sheet was then removed with a torch. (Courtesy MSURR Club Collection, SRI.)

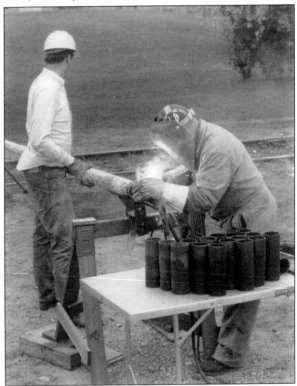

A volunteer steadies one of 1225's many flues while Ken Pelton welds on a new end. The practice of "safe-ending" was a common one in the steam era, allowing the continued use of the body of a tube or flue that had been previously cut out of the boiler while replacing the ends, which were cut off to get it out. Pelton had done this type of work for the Pere Marquette and Chesapeake & Ohio since 1941, and he volunteered his services with the MSURR Club once the restoration of 1225 began. (Courtesy MSURR Club Collection, SRI.)

Looking like something out of a 1950s science-fiction film, newly elected MSU Railroad Club mechanical foreman Roger Scovill sandblasts the interior of the boiler in order to clean the metal. This process was followed by an Apexior coating to protect the boiler metal. (Courtesy MSURR Club Collection, SRI.)

This photograph from May 23, 1974, was taken from inside the firebox, on the opposite side of the tube sheet from the previous photograph. Volunteers are beginning to reinstall flues in 1225. This photograph was taken through the firebox door, with the stoker pot and thermic syphons in the foreground. (John B. Corns photograph; courtesy MSURR Club Collection, SRI.)

On the extreme opposite end of the 1225, volunteers work on cutting and rolling the ends of the newly re-ended flues. Rolling the ends allows for a cleaner surface for the eventual welding of the flues to their respective tube sheets. (John B. Corns photograph; courtesy MSURR Club Collection, SRI.)

In a unique view, Ken Pelton uses an air hammer with a slotted-end tool to roll the end of the tube in place while the photographer takes his picture from the boiler side of the rear flue and tube sheet. This photograph would be impossible when the locomotive is in operation, as the boiler would be filled with tubes and inaccessible. (John B. Corns photograph; courtesy MSURR Club Collection, SRI.)

MSURR Club members Dean Eicher (left) and Jerry Leaders work on grinding the valve seats on the throttle assembly of 1225 sometime in 1974. MSURR Club volunteer Don Childs helped Eicher build this from a diagram in an old engineering handbook. It is assumedly a pretty warm day, as everyone is in short-sleeve shirts and has short hair. (Courtesy MSURR Club Collection, SRI.)

This gives another view of just how tight the confines were when working on 1225 on MSU's campus. Here, the nearly 1,000-pound side rods have been removed for further work. These side rods are integral to the running gear of the locomotive and mount to the large protruding crank pins wrapped by the tarps seen in this photograph. (John B. Corns photograph; courtesy MSURR Club Collection, SRI.)

An unidentified volunteer in an MSU jacket and Dean Eicher remove the valve spool from the large cylinder on the engineer's side of 1225. In the early days of the MSURR Club, work was done with whatever was on hand—in this case, a large chain and a two-by-four as leverage. (Aarne Frobom photograph; courtesy SRI Collection.)

Volunteer Pete Camps oversees Norm Burgess (left) and Chuck Julian, who are holding up volunteer Mark Campbell as he bucks a rivet for boilermaker Ken Pelton on May 12, 1974. Even now, getting to the front rivets on a Lima firebox is an exercise not unlike gymnastics. (Steve Reeves photograph; courtesy MSURR Club Collection, SRI.)

As the 1975 academic year wound down, most MSU students were probably thinking about summer break, but the dedicated crew of the MSURR Club was getting ever closer to a day that they had hoped to see for several years: fire-up day. Appliances were reapplied, boiler tubes were welded up, stay bolts and rivets were bucked (pounded in place); whatever it took to prepare for the event had been done. Here, Chuck Julian takes a brief rest from that work, turning one of the air tanks into a makeshift seat, while Jim Sneed has his back to the camera. (Steve Reeves photograph; courtesy MSURR Club Collection, SRI.)

Several years earlier, in November 1972, the club performed a hydrostatic pressure test of the boiler. The results of that test determined the need to remove all of the tubes and flues, safe-end, repair, and reinstall them before steam could be built up in the boiler. A classic Mack fire truck from the East Lansing Fire Department helped Randy Paquette and Jerry Wilson load 5,000 gallons of water into 1225's boiler. Visible at the rear of the cab is the security door added by MSU. (John B. Corns photograph; courtesy MSURR Club Collection, SRI.)

It is October 5, 1975, and many MSU students have just been rudely awakened by the sound of a steam whistle. Why? PM 1225 just had her first fire-up under steam in nearly 24 years, after volunteer Sam Williams lit the fire at 4:00 a.m. that morning. As can be seen in the photograph, the blower has been turned up, smoking out the pine tree just in front of it. The large single piece of coal that once held the commemorative plaque next to the engine mysteriously disappeared on this day. (John B. Corns photograph; courtesy MSURR Club Collection, SRI.)

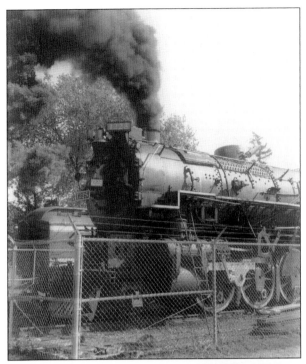

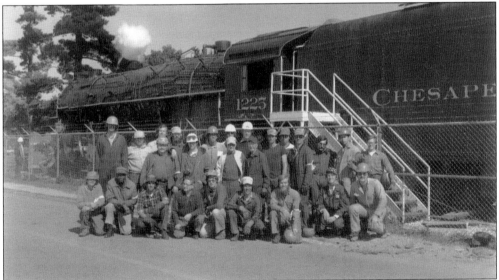

Proud MSURR Club members pose with the newly fired-up 1225. From left to right are (first row) David Jones, Sam Williams, John Titterton, Ken Pelton, Norm Burgess, Jeff Wells, Jim Sneed, unidentified, and John B. Corns; (second row) Mark Campbell, Dave Oliver, Herschel Christiansen, and Sam Chidester; (third row) Roger Scovill, Jerry Willson, Craig Riggenberg, Pete Camps, Aarne Frobom, Dean Steede, Kevin Keefe, John Hall, unidentified, Bruce Wilmoth, Chuck Julian, Steve Derocha, and Bruce Kelly. Herschel Christiansen was a boilermaker for the Pere Marquette, and he had inspected 1225 on its delivery day in 1941. Sam Chidester was a PM locomotive engineer who operated 1225 and the other Berkshires. (John B. Corns photograph; courtesy MSURR Club Courtesy SRI Collection.)

Even after the first steam-up, much work remained, including finishing up the work on the remainder of the 54 superheater units. Here, Aarne Frobom works on cleaning one of the ends of the superheater unit that fits into the manifold. The pace of work had quickened considerably for a few months in 1975, after the American Freedom Train Foundation inquired about the possible use of 1225, but they selected a different engine. (Courtesy MSURR Club Collection, SRI.)

Volunteer Roger Scovill works on cleaning the superheater manifold, which the superheater unit head (seen being worked on in the previous photograph) fits into. (Courtesy MSURR Club Collection, SRI.)

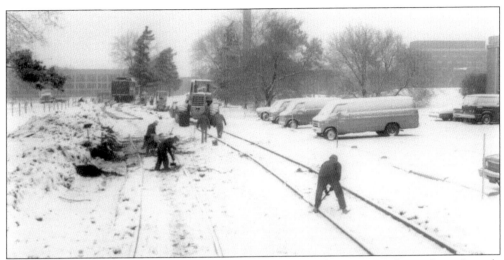

Eventually, the work of the MSURR Club began to outgrow the site at Michigan State. In early 1976, plans were made to search for a new home for "Project 1225." Club president Chuck Julian met with incoming MSU president Edgar Hardin to discuss the future of 1225. Hardin indicated that the university was not interested in running a steam locomotive, but that it might donate the engine to a 501(c)3 nonprofit. The Michigan State Trust for Railway Preservation (MSTRP) was then formed, 1225 was donated to it by MSU, and a campus exit strategy was formulated. Here, MSTRP members tear up the track next to the engine while Williams Bros. Asphalt Paving of Ionia, Michigan, uses a front-end loader to move material. (Dave Parker photograph; courtesy MSURR Club Collection, SRI.)

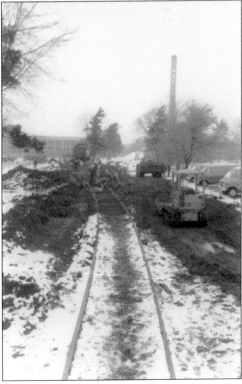

Work continues to free 1225 from her display site at Michigan State. In the background are the MSU Shaw Lane Power Plant and the football stadium, with the storied "MSC" smokestack visible in the distance. This smokestack, along with a similar one labeled "MAC," for Michigan Agricultural College (MSU's original name), were familiar sights to generations of Spartan football fans. (Dave Parker photograph; courtesy MSURR Club Collection, SRI.)

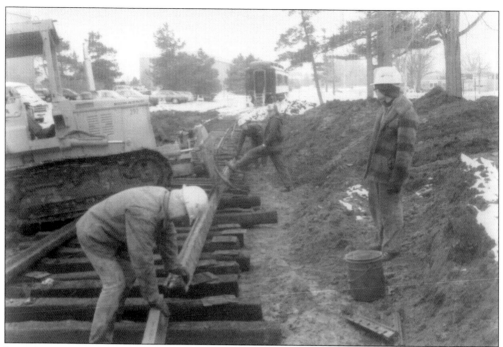

In order to get 1225 out from her display track, a process similar to the one used in 1957 was undertaken. This involved actually grading a rail bed and constructing track tie by tie and rail by rail, using materials from the Power Plant spur next door, which had recently been retired. Here, volunteers work with Williams Bros.' bulldozer in the cold to get it built. (Dave Parker photograph; courtesy MSURR Club Collection, SRI.)

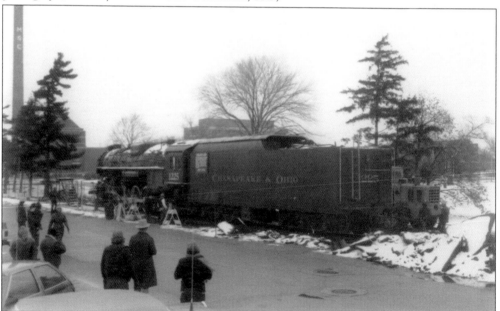

A group of onlookers has come out to see how the process of freeing 1225 is going. It is not every day that once can see a steam locomotive move on a college campus. (Dave Parker photograph; courtesy MSURR Club Collection, SRI.)

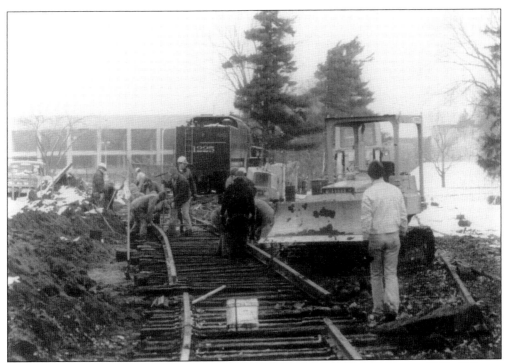

Just a few more feet, and 1225 will be connected to live rail for the first time since 1957. Williams Bros. Asphalt Paving provided a bulldozer to help with the move, as well as a front-end loader and a tri-axle dump truck. (Dave Parker photograph; courtesy MSURR Club Collection, SRI.)

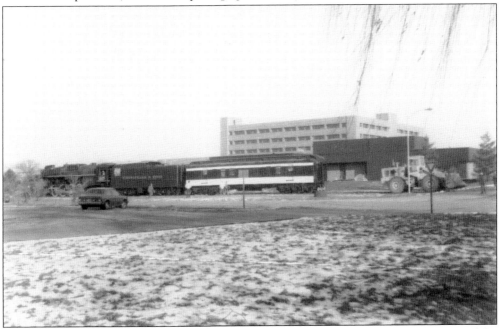

She moves! Using a front-end loader for propulsion, MSTRP begins the move of No. 1225 and the former GTW RPO car off campus to a temporary siding near Trowbridge Road in East Lansing in 1981. (Dave Parker photograph; courtesy MSURR Club Collection, SRI.)

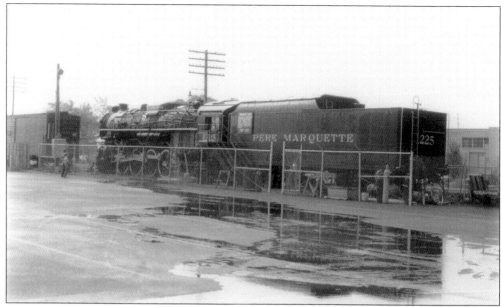

The 1225 sits in her temporary home on the MSU spur next to the Michigan High School Athletic Association (MHSAA) parking lot in East Lansing. No. 1225 arrived at this location on Trowbridge Road, just west of Harrison Road, on May 26, 1981. In the far left of this photograph, one can see the former Pere Marquette Railroad automobile car, 72332, which MSTRP acquired for its growing collection of parts and tools needed for the restoration of the engine. (Courtesy MSTRP Collection, SRI.)

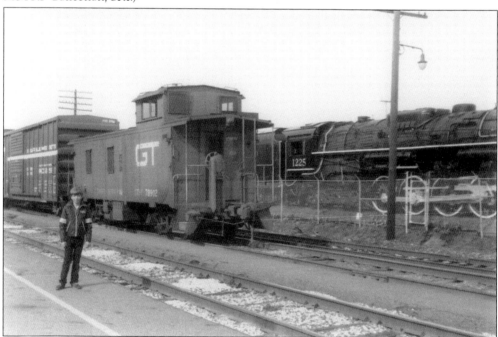

A GTW train and its caboose pass PM 1225 at Trowbridge Road sometime in 1982. MSTRP would store 1225 at the MHSAA parking lot location for nearly two years while it searched for a new home. (Courtesy MSTRP Collection, SRI.)

After a great deal of searching, a new home for the locomotive and its restoration was found. The Ann Arbor Railroad, which had recently gone bankrupt, was acquired by the State of Michigan. Along with it, the state acquired its former shop complex in Owosso, roughly a half hour east of Lansing. The shop complex still had several of its steam-era tools available. Here, 1225 waits on the GTW mainline on February 19, 1983, for the move to her new home. From left to right are Neal Puetz, Brian Osmer, Andy Adams, and Bill Wilson. (Courtesy MSTRP Collection, SRI.)

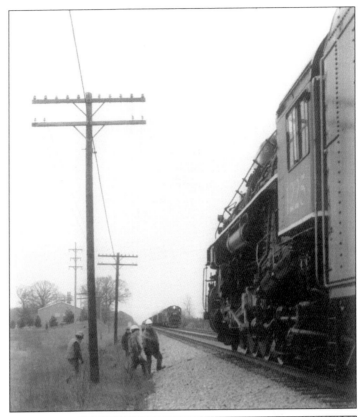

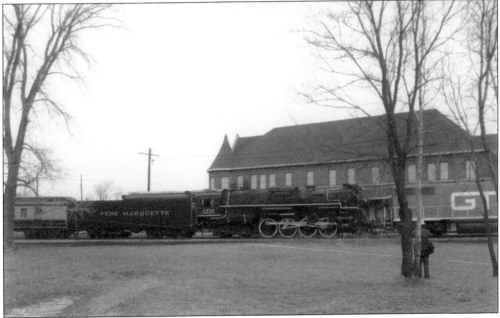

PM 1225 was hauled through Durand on its way from East Lansing to Owosso. Here, it passes the classic Grand Trunk Western two-story "witch's hat" depot, one of the more iconic ones in the country. (Courtesy SRI Collection.)

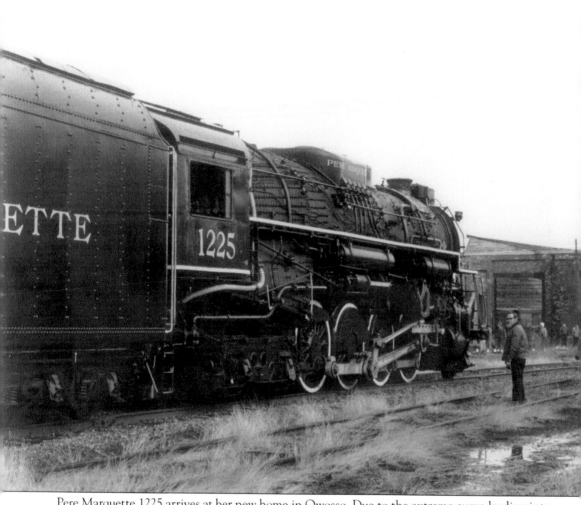

Pere Marquette 1225 arrives at her new home in Owosso. Due to the extreme curve leading into the building, 1225 had to sit outside and wait while volunteers tore up this track and rebuilt it. With a new home, actual steam-era machine tools, and a new sense of purpose, the heat was on to get 1225 restored to operation. (Courtesy SRI Collection.)

Four

THE OWOSSO ERA, THE POLAR EXPRESS, AND BEYOND

As the summer of 1983 progressed, MSTRP had much to be proud of. The locomotive had been moved off campus and had a new home in the former Ann Arbor Railroad backshop in Owosso. Finally, the volunteers could work with a roof over their heads, but it also meant another thing: a shift in priorities. Whereas everything before had focused on the restoration of the locomotive, MSTRP now had a very tired building to take care of. A leaking roof, broken windows, no heat, and walls with several missing bricks meant the volunteers had their work cut out for them. What it did have was lots of machine tools from the steam era. The 1225's rebirth could now move ahead.

Leading this charge was Rodney Crawford, who, as chief mechanical officer, helped get the group organized in its new home. With new energy, the MSTRP volunteers made a massive two-year push to get the locomotive back to moving under its own power in 1985. From here, the group never looked back, getting the engine to haul its first trip to Chesaning and St. Charles in 1988, and doing a test run back to home rails and the old Wyoming Shops in 1990. The 1225's real chance to shine came in 1991, with an invitation to the National Railway Historical Society convention in Huntington, West Virginia. PM 1225 embarked on the longest trip of its career, joining up with fellow NKP Berkshire 765 to give several thousand spectators a show they would never forget. The sky seemed the limit for both MSTRP and the 1225.

The truth was, the Huntington trip showed just how much work was still to be done. The failure of one of her thermic syphons meant that the locomotive would not run again for nearly three years. The group dusted off the blueprints and made new syphons. In 1995, another opportunity came, with an invitation to the opening ceremony of Steamtown, but complications with a tunnel in Detroit meant that 1225 was unable to attend. These setbacks illustrate the realities of working on a 1941 steam locomotive nearly 50 years after her brethren went to scrap. There are moments of opportunity, setback, glory, and failure. But, always, MSTRP and 1225 have persevered, appearing in the Warner Bros. film *The Polar Express* and hosting one of the largest steam events of the 21st century. No matter what, 1225 and those who have cared for her can continue to do one thing after all they have been through: believe.

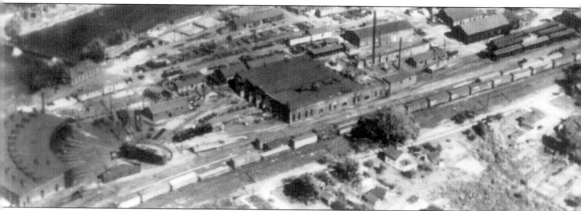

This aerial view shows the Owosso shop complex of the Ann Arbor Railroad in the early 1940s. Typical of many shop complexes of the steam locomotive era, nearly 1,000 people were once employed here by the Ann Arbor, repairing and maintaining steam locomotives and other rail equipment. When the Ann Arbor ended steam locomotive operation in 1951, it very quickly abandoned and tore down its roundhouse, shown in the left of this photograph, but it continued to use much of the remainder of the shop complex for maintaining other equipment, including the newly arrived diesel locomotives. Amazingly, a portion of this complex continued to exist nearly 30 years later, long enough that when 1225 went looking for a new home in 1982, it could be saved and returned to its original purpose. (Courtesy MSTRP Collection, SRI.)

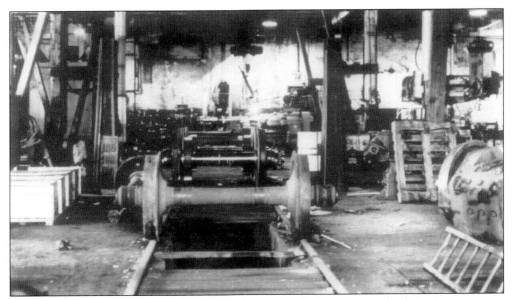

The Ann Arbor's Owosso backshop was truly a magical place—a step back in time to an era when steam was king. Built in 1888, it was once a much larger structure, but by the time MSTRP arrived in 1982 the complex had seen better days. Although it still had all its original tools, the building itself had been reduced to a three-stall tender shop, and even this had suffered from severe neglect. MSTRP quickly got to work cleaning it up and making it usable; however, many different parts were scattered across its interior. (Courtesy MSTRP Collection, SRI.)

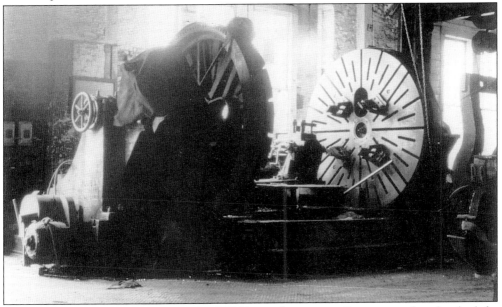

One of the most important aspects of MSTRP's new location in Owosso was that they had, for the very first time in their history, access to large machine tools. More importantly, these tools were designed specifically for maintaining steam locomotives. One of the largest was the 90-inch Niles wheel lathe, shown here. This enormous machine was designed to turn and hone wheels as small as those on a typical freight car, but its real importance was in being able to turn the large drive wheels of locomotives the size of 1225. (Courtesy MSTRP Collection, SRI.)

PROJECT 1225

The Newsletter of
THE MICHIGAN STATE TRUST FOR RAILWAY PRESERVATION, INC. and
THE MICHIGAN STATE UNIVERSITY RAILROAD CLUB

Number 62
Winter 1986

SHE MOVED

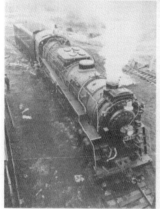

ON NOVEMBER 30, 1985, at 5:19 p.m. EST, Pere Marquette Berkshire number 1225 moved forward about three feet on shop track number 2 under her own steam. This was the first time in 34 years that 1225 was a functioning piece of railroad motive power. This first move under steam was part of a combination "dry-out" and testing activity. It also fulfilled a commitment made by the Trust, to its members, to move 1225 under her own steam in 1985.

A short time later she backed up approximately 45 feet. At 5:27 p.m., 1225 moved forward to the original spot. Those in attendance applauded and the crew was both elated and in somewhat of a state of shock. The whistle sounded the classic grade crossing signal and the shut down operation commenced.

This eight minute period in the restoration of 1225 was truly a major milestone, but can only rank equally with other such milestones as:

— The decision to start the restoration
— The re-flueing of the boiler
— The first firing of the boiler
— The rebuilding of the superheaters
— The move of 1225 off the MSU campus
— The move to Owosso
— The activities required to make the Owosso site and machines functional

A mighty "well done" must be extended to all who participated in these activities, both physically and financially.

1225 billows steam and smoke as it stretches out on shop track No. 2.
Photo by Ronald Hagemeister

The hard work of the MSURR Club and MSTRP finally came to fruition on November 30, 1985. At 5:19 p.m., 1225 moved forward three feet on shop track number two, under steam, for the first time since 1951. The reality was, however, that it was also the closing of a chapter. From this point forward, the locomotive crew would need to think about something they never had to before: how to operate the locomotive as safely and economically as possible. (Ron Hagemeister photograph; courtesy MSTRP Collection, SRI.)

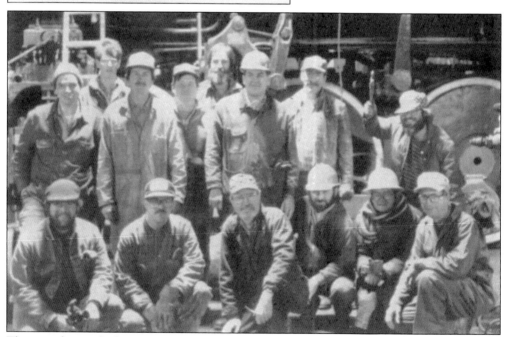

The crew that made the push to operation possible is seen here in 1985. From left to right are (first row) Chris Northcott, Bill Perry, Rod Crawford, Pat Wheeler, Dave Jones, and Keith Welcher; (second row) Dave Templeton, Karl Hanold, Dennis Braid, Dave Parker, Augie Janke, Bill Rann, F.X. Rosica and Andy Adams. (Courtesy MSTRP Collection, SRI.)

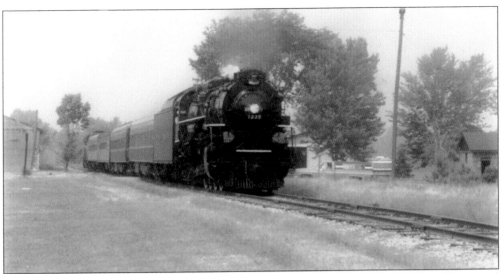

Work continued on the locomotive through 1986, with the idea of moving toward eventual operation. Soon, an opportunity presented itself via the former New York Central line running north out of Owosso. Originally part of a rail line that stretched from Jackson to Bay City, it was severed in the mid-1970s when the Swan Creek Bridge was removed. By the time MSTRP began to use it in 1988, the line had been cut back to between Owosso and St. Charles, approximately 17 miles. Trips were run under the Shiawassee Valley name from Chesaning to St. Charles and back for several summer weekends in the mid-to-late 1980s. Here, 1225 hauls a four-car train out of St. Charles in the summer of 1988. (Courtesy MSTRP Collection, SRI.)

Riders anxiously wait to board the 1225 in downtown Chesaning in 1988. At the time, Chesaning was one of the more popular tourist destinations in Michigan, with a large group of antique shops and several outdoor fairs. It continues to be the home of the Chesaning Showboat, which has hosted countless entertainment acts from around the country. (Courtesy MSTRP Collection, SRI.)

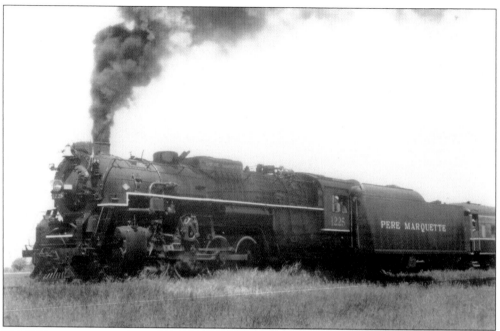

PM 1225 steams across the countryside of mid-Michigan in this 1987 photograph. Even though she was back under steam, the MSTRP volunteers still had quite a bit of work to do, as can be seen by the still-to-be finished, missing boiler jacketing on the rear of the engine. (Courtesy MSTRP Collection, SRI.)

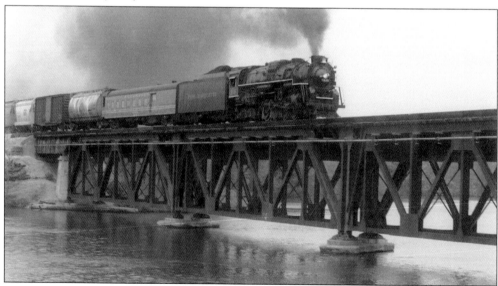

The Shiawassee Valley trips continued on the St. Charles branch through the late 1980s, but the MSTRP volunteers were anxious to get 1225 back out on the high iron. The opportunity finally presented itself in early 1990, when CSX Transportation gave the go-ahead for MSTRP to take 1225 on some test runs on the old Pere Marquette line from Howell to Grand Rapids. She is seen here at speed crossing the Cook Bridge over the Thornapple River on October 20, 1990. For the first time in 39 years, 1225 was doing what she was designed to do, haul freight at speed. (Jodi Hak photograph; courtesy MSTRP Collection, SRI.)

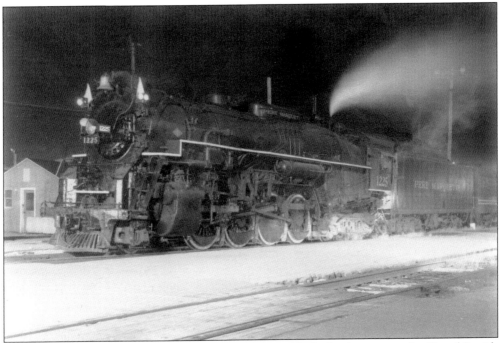

Pere Marquette 1225 rests in the former PM Wyoming Yard after her run to the Grand Rapids area on the night of October 20, 1990. This was the first time a 1200-class Berkshire had been in the yard since 1961. (Jodi Hak photograph; courtesy MSTRP Collection, SRI.)

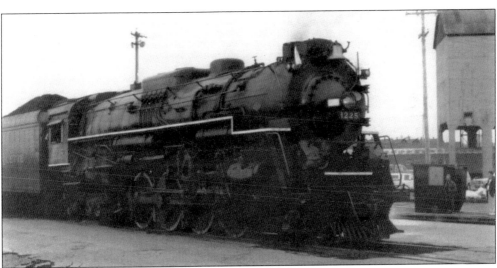

The 1225 is ready to depart the CSX yard in Wyoming for Lansing and Howell on October 21, 1990. In the 1950s, no one would have thought the engine would ever reappear at this spot. (T.L. Chubinski photograph; courtesy MSTRP Collection, SRI.)

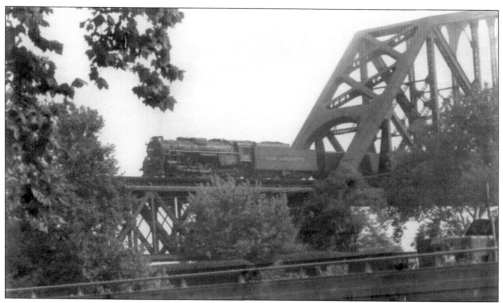

The test run to Grand Rapids was so successful that CSX agreed to allow MSTRP to take 1225 on the largest trip it had ever made. Just one year later, 1225 headed for Huntington, West Virginia, and the National Railway Historical Society (NRHS) convention. A massive undertaking, it required the engine to cross three state lines in the process. Here, the 1225 crosses the famous Chesapeake & Ohio Railway two-track truss bridge at Sciotoville, Ohio. (Courtesy MSTRP Collection, SRI.)

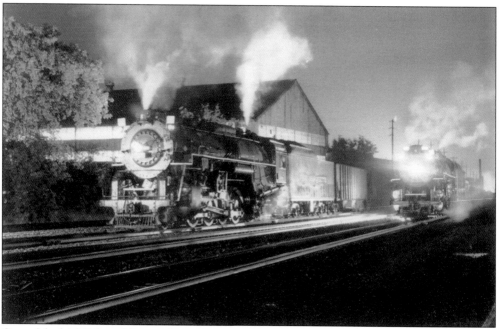

One of the highlights of the trip from Owosso to Huntington was meeting fellow Lima Berkshire Nickel Plate 765 at the two locomotives' birthplace in Lima, Ohio. Here, in the gathering twilight, NKP 765 meets PM 1225 and its revenue freight train, with the Lima Locomotive Works in the background. (Courtesy MSTRP Collection, SRI.)

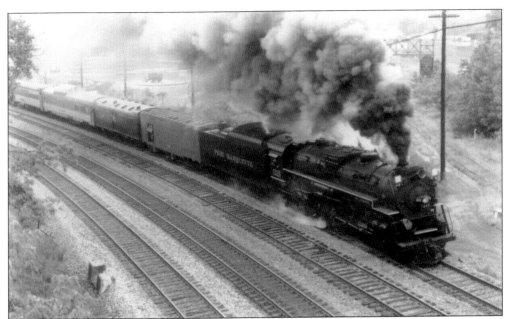

PM 1225 hauls a 34-car passenger train across the CSX four-track mainline during the NRHS convention in summer 1991. The engine was truly put through its paces, which was amazing because she was missing one row of superheater tubes when she did it. Unfortunately, one of her thermic syphons, which dated back to her 1941 construction, failed during this day of activity, making firing the engine extremely difficult. (Courtesy MSTRP Collection, SRI.)

The highlight of the 1991 NRHS convention was the side-by-side running of two Lima-built Berkshires doing exactly what they were designed to do. Here, NKP 765 hauls a brand-new set of empty hopper cars, while PM 1225 paces her with a 34-car passenger train at Hurricane, West Virginia. (T.J. Gaffney photograph.)

PM 1225 was somewhat worse for wear after the Huntington NRHS event. In an act of kindness, the Potomac Chapter of the NRHS gave MSTRP a grant for $7,800 towards the repair and replacement of 1225's thermic syphons. Along with gifts from trust members and revenues from the NRHS event, the nearly $18,000 needed for the fabrication and repair was covered by early 1993. Here, patternmaker Jerry Dosh and his wife, Joanne, pose with the polyester pattern for the syphon. This was used to make steel castings, known as mandrels, for the new syphons. (Mike Dobosenski photograph; courtesy MSTRP Collection, SRI.)

MSTRP volunteer Mark Holton contemplates the mandrels made from the patterns shown right. At the time, these mandrels were the first made for any steam locomotive since the steam era, or roughly 1960. The syphons are made of plate steel, which has to be formed by heating and then beating the metal around the mandrel. The tool had to be made in two pieces, otherwise it could not be removed from the finished syphon. (Mike Dobosenski photograph; courtesy MSTRP Collection, SRI.)

One of the key missions of MSTRP is to educate the public about steam locomotives. Starting in 1995, No. 1225 truly became a teaching tool for several individuals who paid for the opportunity of a lifetime: to drive a steam locomotive. Here, in August 1996, longtime volunteer Pat Dobosenksi operates the 1225 under the watchful eye of engineer Joe Sigafoose. (Mike Dobosenski photograph; courtesy MSTRP Collection, SRI.)

Sometimes hard work and effort really do pay off and dreams really do come true. Such is the case here for MSURR Club member No. 2, Randy Paquette, who poses in the cab of the locomotive he helped restore. (Mike Dobosenski photograph; courtesy MSTRP Collection, SRI.)

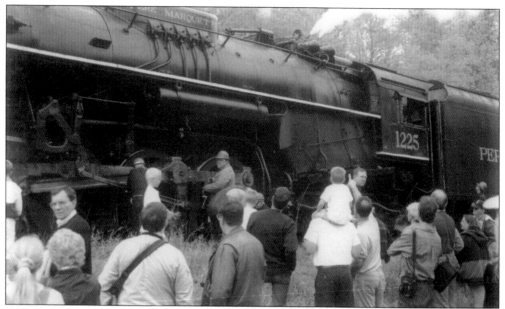

Anyone who spends a lot of time operating a machine that has been obsolete for years probably asks sooner or later, "Why do I do this?" The answer can be seen in this photograph. The people here have come to Mount Pleasant, Michigan, in the hot summer of 1999 to experience what is best described as living history. If not for the efforts of the Steam Railroading Institute and its volunteers, most of these people would never have seen a steam locomotive chug into town and out of the past. It is a tangible way to connect to those who came before us, and to experience the wonder and awe that is big steam. (Courtesy SRI Collection.)

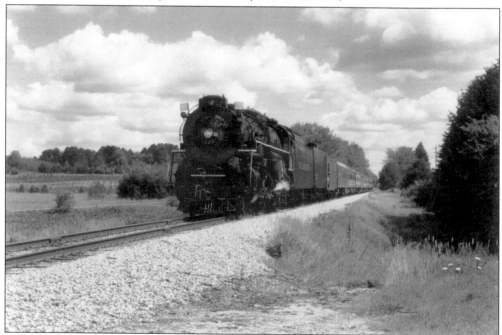

With a clean stack and a large passenger train in tow, 1225 heads for Cadillac, Michigan, on former Ann Arbor Railway trackage in July 2001. (Courtesy T.J. Gaffney collection.)

As the 20th century came to an end, it was clear that MSTRP was in need of a new facility to maintain 1225. The 110-year-old Ann Arbor backshop had become difficult to maintain, and it was clear that what SRI truly needed was a structure where the entire locomotive could be worked on under one roof. In addition, severe contamination issues from previous railroad use led to the need for environmental rehabilitation. Executive director Dennis Braid stands next to the building just prior to its demolition, in August 2000. (Courtesy SRI Collection.)

Demolition is nearly complete in this September 2000 view. On a brighter note, the newly relocated turntable from New Buffalo, Michigan, sits in the foreground. Within the next few years, it would be reinstalled on roughly the same site as the Ann Arbor Railway's original turntable, removed in the 1960s. This turntable, built for the Pere Marquette, was originally 90 feet long, but it was extended 10 feet by the SRI to be able to accommodate the full length of 1225 upon reinstallation. Today, it is one of the centerpieces of the Steam Railroading Institute's property in Owosso. (Kevin Mayer photograph; courtesy SRI Collection.)

The early 2000s were a period of profound change and opportunity for all those involved with 1225. The MSTRP decided to change the name it did business under to better reflect its mission of education, and the Steam Railroading Institute (SRI) was born. A key moment came when SRI purchased property from the Tuscola & Saginaw Bay (TSBY) Railway, who had operated the former Ann Arbor lines for the state of Michigan since 1983. This allowed SRI to put down permanent roots and begin to truly shape its destiny. Here, SRI and TSBY management sign the papers to begin that process. From left to right are (seated) Dennis Braid, executive director; TSBY owner Jim Shepherd; (standing) Kevin Mayer, chief mechanical officer; Bill Berkompas, board president; and Steve Knapp, board member. (Dottie Berkompas photograph; courtesy SRI Collection.)

Acquired with the new property was much-needed frontage and a structure that would soon become its visitor center. Leased by Bruckman's Moving & Storage Company for nearly 30 years, this concrete-block structure was built at 405 South Washington Street in Owosso in the 1920s. SRI would have nearly a year of work to do to convert the structure into its visitors' center. (Courtesy SRI Collection.)

Soon after the property purchase, the production team for Tom Hanks, Robert Zemeckis, and Warner Bros. contacted SRI and selected PM 1225 for the overall image of its new animated feature movie *The Polar Express*. Eventually, a team from Lucas Digital's Skywalker Sound unit was selected to create the movie's soundtrack. On July 20, 2004, Skywalker Sound's Tim Nielson and Will Files came to SRI to record the sounds of 1225 under operation for the movie. Here, Nielsen (left) and Files pose with the 1225 on the turntable. (Lawerence Sobczak photograph; courtesy SRI Collection.)

The SRI crew poses with the Skywalker Sound team. From left to right are (in the cab) Bill Wilson and Richard Greter; (first row) Kevin Mayer, Robert Gruich, Steve Wasiura, Dennis Braid, John Hansen, Paul Hahn, and Jeff Lis; (second row) John Peters, Rodney Crawford, Duane Thompson, Tim Nielson, Will Files, Chad Thompson, John Omnaas, Fred Stevens, John Gramling, Chris Kurzweil, Marv Schlicter, and Charlie Lumpert. (Lawerence Sobczak photograph; courtesy SRI Collection.)

Photograph charters are one of the more unusual assignments for 1225. Chartered by groups such as Historic Transport Preservation and Peter Lerro Productions, photographers from Germany, South Africa, and England have come to take photographs of 1225. Historic scenes are recreated using vintage automobiles, actors, and a 1940s freight train consist owned by SRI. Here, 1225 approaches the timeless elevator at Carland, Michigan, while volunteers pose next to Chevrolet pickup trucks. From left to right are Heather and Thomas Gaffney and Greg Udolph. (Peter Lerro photograph.)

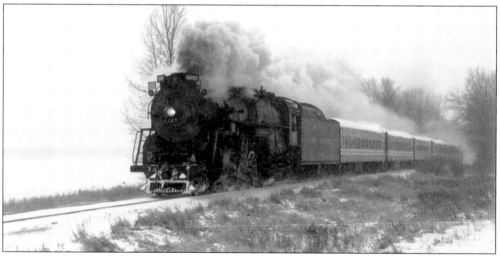

The most important events on SRI's calendar are the weekend trips of the North Pole Express. These began in 2004 after SRI's involvement with the making of *The Polar Express*. While Chris Van Allsburg, the author of the original book, was only two years old when the C&O retired 1225 in his hometown of Grand Rapids, he remembers seeing 1225 while attending a few MSU football games as a teenager in the mid-1960s. From 2004 to 2012, the trips operated to the Saginaw County Fairgrounds near Chesaning using former New York Central tracks. In 2013, the destination became Ashley, on the former Ann Arbor line. Close to 80,000 patrons have traveled on SRI's North Pole Express. Here, 1225 powers one of the winter trips in December 2008. (Courtesy T.J. Gaffney collection.)

Five

THOSE THAT MADE IT HAPPEN

At their heart, stories about railroads are almost always stories about people—the people who designed and built them, the people who operated them, the people who rode them, and the people who have preserved and restored them. Since 1970, thousands of people have volunteered hundreds of thousands of hours and donated hundreds of thousands of dollars to support Pere Marquette 1225. Unfortunately, space does not permit us to cover all 3,000 volunteers who have worked on 1225, but the following pages show a few of the people who have cared for PM 1225 since she was built in November 1941.

Steam engines have always been popular backdrops for group photographs, and even professional railroaders are no exception. Delivery day for a new locomotive was filled with inspections and testing, and, on this day in October 1941, employees of Lima Locomotive, the Pere Marquette Railroad, and the Advisory Mechanical Committee (AMC) engineering department pause for a group photograph next to PM 1220. Pictured from left to right are (first row) two unidentified PM employees, AMC's L.H. Booth, boiler inspector Mr. Beansworth, PM inspector A.H. Ash, and boiler inspector Pat Golden; (second row) two unidentified employees, Mr. Woodworth, PM inspector E.C. Rice, Mr. Trumbull, Herbert Gibbs, an unknown PM inspector, John Lipes, AMC's chief mechanical engineer Mike Donnovan, and chief boiler inspector Bob Culbertson. (Courtesy Allen County Historical Society.)

Representing the many thousands of employees who came to "the Loco" as Ohio farmers, immigrants, or family members of other Lima employees, three boilermakers drill holes for rivets or stay bolts in the firebox of a Berkshire destined for the C&O during construction of order 1122 in the mid-1930s. (Courtesy Allen County Historical Society.)

Employment on the nation's class-1 railroad network peaked at over two million employees in 1920. At that time, the total population of the United States was just over 100 million, so a considerable percentage of American households earned their living from rail transportation. Posing here at the Richmond Hill helper shanty in 1947 with Berkshire 1213, Pere Marquette employees (from left to right) Roy Walters, Frank Harmsen, and Al Sirrabbin continue that proud tradition of railroad service. (Courtesy SRI Collection.)

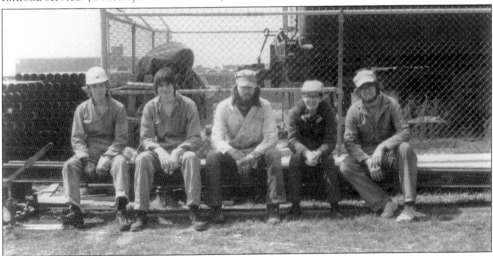

Youth is definitely on display in this photograph from the MSU campus, as five members of the MSU Railroad Club take a break from their work in this undated photograph. The new pipe material stacked neatly at the left would suggest this is probably during the first re-tubing of 1225's boiler in 1973–1974. In this era, the young students were guided by experienced railroaders or retirees who had worked on steam locomotives 25 years earlier. From left to right are Phil Atwater, Dave VanDeGrift, Pete Camps, Dave Jones, and Norm Burgess. (Courtesy MSURR Club Collection, SRI.)

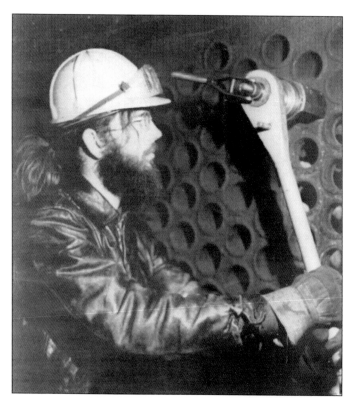

MSURR Club vice president Pete Camps uses the Weidike tube cutter to remove the old flues in 1225's boiler. Tragically, Camps was killed in a motorcycle accident near East Lansing on July 7, 1977, while still a zoology student at MSU. (Courtesy MSURR Club Collection, SRI.)

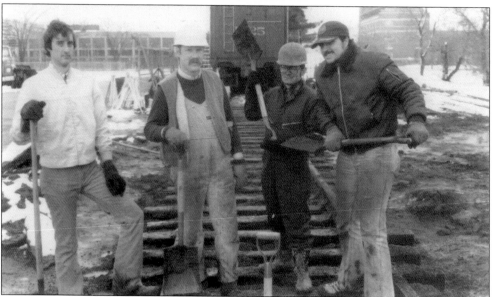

Volunteers with the MSURR Club or the Steam Railroading Institute have many other duties in addition to locomotive maintenance, and today's job is to be a "gandy dancer" on the track gang. In this photograph, taken while laying track to remove 1225 from the display site, members of the MSURR Club pose for the camera on a snowy day in November 1980. From left to right are Jeff Nelsen, Randy Paquette, David Jones, and Steve Medvik. (Courtesy MSURR Club Collection, SRI.)

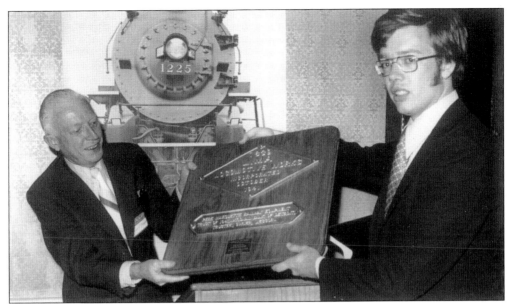

A signature event during the club's first 30 years of existence was the annual dinner. Organization business was conducted and food and fellowship were enjoyed in a variety of restaurants and halls in mid-Michigan locations such as Owosso, Frankenmuth, Chesaning, Crossroads Village, Flint, and, of course, Lansing. Guest speakers have included astronaut and Michigan native Jack Lousma, Smithsonian transportation curator William Withuhn, and Union Pacific steam manager Steve Lee. Here, at the second annual dinner in 1973, club president, MSU student, and future editor of *Trains* magazine Kevin P. Keefe presents an award to the legendary editor of *Trains*, David P. Morgan. (Courtesy MSURR Club Collection, SRI.)

This familiar scene would be recognized by any volunteer or one-time visitor to Owosso between 1983 and 2001. Taken inside the small, whitewashed crew quarters building, the weekend crew gathers for lunch in this undated photograph. Dick Hak is in his traditional spot at the head of the table, with fellow railroader Frank Troge and MSURR club member Rich Hodges to his left, followed by Bill Rann and Lee Hillier. (Courtesy MSURR Club Collection, SRI.)

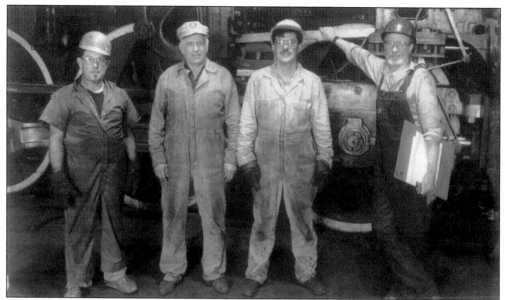

Wearing coveralls containing just as much dirt as their ancestors would have worn, four volunteers pose in front of 1225 in the Owosso machine shop. C&O car inspector Frank Troge (second from left) and chief mechanical officer Rod Crawford (far right) pose with two other volunteers. Hailing from Iowa and after serving in the Navy as a fighter pilot, Crawford, Rod received his engineering degree and worked at the Ford Tractor plant in Birmingham, Michigan, for many years. (*Saginaw News* photograph by David Sommers; courtesy SRI Collection.)

Rod Crawford enjoys yet another day outside around an operating steam locomotive. Crawford remained as a volunteer and, later, as a board member until declining health and retirement led to his moving to Texas to be with family. Rod passed away in Houston on May 22, 2013. (Mike Dobosenski photograph; courtesy SRI Collection.)

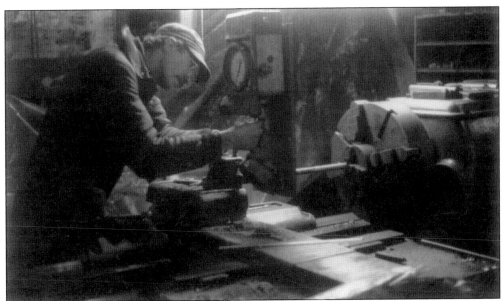

Mark Holton was a local farmer, beekeeper, and machinist who could fix almost anything. When 1225 needed to add a speedometer to maintain compliance with modern regulations, Holton took on the task of fabricating the spring and wheel mechanism that would ride on one of the driving wheels to transmit revolutions to the speedometer. He is shown here at the workbench with the speedometer in the background. Holton passed away in 2002 at the all-too-young age of 44. (Courtesy SRI Collection.)

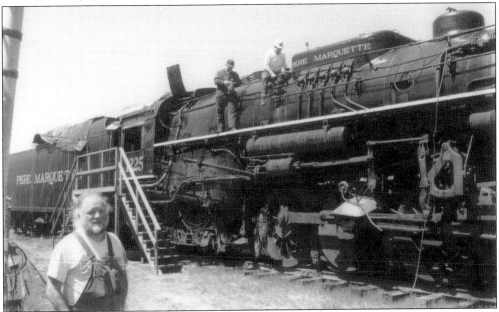

Any nonprofit organization depends on dedicated volunteers who spend many hours of their free time working for the association. Three of SRI's frequent volunteers can be seen in this photograph, as Steve Knapp (left) and Jeff Lis come down from the turret of the locomotive and John Omnaas stands in the foreground. Omnaas worked in the chemistry labs of the University of Michigan, and he too passed away too soon, in 2003. (Courtesy SRI Collection.)

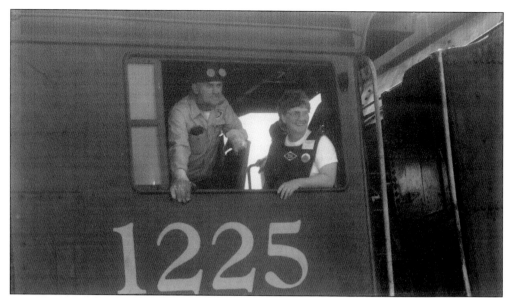

As with most industries and professions, railroad employment often follows family lines, with brothers, uncles, sons, and daughters often employed by the same railroad. Family groups have also volunteered with the Michigan State Trust for Railway Preservation throughout its history. Dick Hak was employed as a switchman and conductor for the C&O in Saginaw, and he was one of the early firemen for 1225 in the 1980s. His wife, Leona, served as membership secretary for many years, and their daughter Jodi was office manager for SRI. (Jodi Hak photograph; courtesy Hak family collection.)

Several volunteers take a rest during the 1991 Huntington NRHS convention. From left to right are Dennis Braid, Lee Hillier, Mark Holton, Rich Hodges, Norbert Weber, Pat Wheeler, Bill Berkompas, Phil Berkompas, Dieter Weber, and Frank Troge. (Courtesy SRI Collection.)

While maintenance crews and fireman are volunteers who come from a variety of occupations, engineers for 1225 have always been professional railroad engineers. Joe Sigafoose of Henderson, Michigan, started working for the Ann Arbor Railroad in Owosso and continued on with Ann Arbor successor Tuscola & Saginaw Bay. Volunteering his services as an engineer for 1225, Sigafoose is seen here being interviewed by a reporter from Flint's Channel 12 during one of the Shiawassee Valley dinner train excursions to Chesaning or St Charles. (Courtesy MSTRP Collection, SRI.)

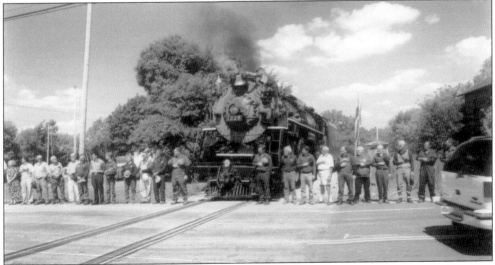

SRI fired up PM 1225 for Sigafoose's funeral in 2002. Here, the funeral procession crosses Henderson Road on a sunny Saturday morning, as SRI members line the road to pay their respects. Sigafoose's trademark green-and-white polka dot "Stormy Kromer" cap rests on the front coupler. From left to right from the lady wearing the dress are unidentified, Bob Stellmach, Dick Hak, unidentified, Andy Adams, unidentified, Rich Hodges, Farol Henkle, Charlie Kricher, Dave Rozeman, Kevin Mayer, Jeff Lis, unidentified, Dennis Braid, Marv Schlichter, Bill Wilson, Richard Witt, Rod Crawford, Bill Berkompas, two unidentified, and Steve Knapp (with the bell). (Courtesy MSTRP Collection, SRI.)

Two more professional railroaders and volunteer engineers take a break under a shade tree on the campus of Alma University in this photograph from May 2008. Charlie Kricher (left) is seen holding his typical white cap, while Bill Wilson wears his red, white, and blue cap. Kricher began his career on the C&O and retired as a regional safety instructor for short line conglomerate RailAmerica's Midwestern operations. Wilson ran freight trains and the "Michigan Executive" passenger service out of Jackson and Lansing for the Penn Central, Conrail, and, later, Norfolk Southern. (Heather Gaffney photograph.)

Duane Thompson and his son Chad pose in the open door of the tool car while working on the maintenance crew during a trip on September 29, 2001. Duane was a longtime member of the Stoney Creek Model Railroad Club, and an MSTRP/SRI volunteer from 1996 to 2006. Chad would later work for a short line railroad in Michigan's thumb. Duane passed away on May 13, 2010. (Courtesy Chad Thompson collection, used with permission.)

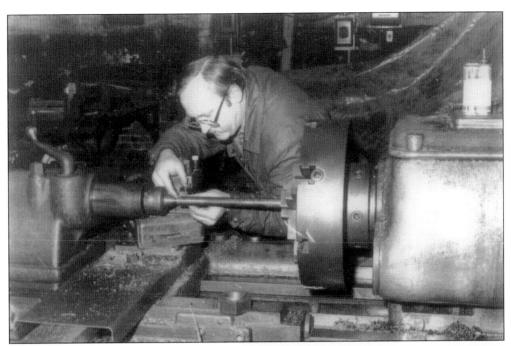

Not everyone is required to be a skilled machinist to work around steam locomotives, but it certainly helps to have one in the group. Norbert Weber has taken care of the machine tools in Owosso and turned metal into a variety of different parts for many years. SRI's machine tool collection is a mixture of equipment that resided in the Ann Arbor shops in Owosso, some Grand Trunk facilities around Michigan, and surplus equipment from automotive factories. All of the equipment has been donated and is now owned by SRI. Norbert's wife, Christine, was the longtime treasurer for MSTRP, and his brother Dieter was also a fireman on 1225 during the early days of excursion service. (Courtesy MSTRP Collection, SRI.)

Steve Knapp and Tom Grace work on one of the electrical generators from 1225. Steam powers turbine blades on one side of the generator, and those turbine blades spin wire coils through magnets to generate the electrical field. The lights on the locomotive run on 32-volt power. (Courtesy SRI Collection.)

Distance does not deter volunteers who want to work on a steam locomotive. Dennis "D.J." Hendrickson (right) first heard about 1225's restoration in 1979 from friends in the MSURR Club. Traveling over 300 miles from Newberry in the Upper Peninsula to Lansing or Owosso, Hendrickson was a maintenance crew volunteer and remains a member to this day. Dave Rozeman (left) hails from the London, Ontario, area, and often used his skills as an auto body mechanic to paint the exterior of 1225 after major overhauls. (Courtesy D.J. Hendrickson collection.)

With a new coat of paint outside and new tubes and flues inside, 1225 and crew prepare to depart for Scranton, Pennsylvania, in July 1995 for the opening of the National Park Service's "Steamtown" complex. Unfortunately, the late discovery of a clearance problem in the Detroit–Windsor railroad tunnel canceled the trip. From left to right are (kneeling) Carol Peterman, Lee Hillier, Dennis Braid, and Jack Peterman; (standing) Dave Bischoping, Dave Rozeman, Joe Sigafoose, Bill Wilson, Mark Holton, Andy Adams, Rod Crawford, Steve Knapp, Rich Greter, Rich and Marcie Hodges, Dave Komraus, Norbert and Christine Weber, Leona, Jodi, and Dick Hak, Jasper Lille, Frank and Dale Nagele, Gary Knudsen, Aarne Frobom, Tom Grace, and Bill Simmons. (Courtesy SRI Collection.)

While many maintenance duties around a steam engine are quite heavy and complex, others are much smaller, but still just as important. Here, 1225 fireman Jeff Lis cleans out one of the water glasses in 1225's cab, an important safety appliance that must be kept free of dirt and scale. (Courtesy SRI Collection.)

From left to right, chief mechanical officer Kevin Mayer poses with Andy Adams, Paul Hahn, and Stefan Lis in the cab of 1225. Like several other members, Stefan is a second-generation member of MSTRP. His father, Jeff Lis, is a longtime volunteer. (Marv Schlicter photograph; courtesy SRI Collection.)

Board members Gary Knudsen (in cab) and Aarne Frobom are seen preparing the cab for tours during an open house event. Frobom is a founding member of the MSURR Club (member No. 7), and has stayed with 1225 as an active board member, newsletter editor, and association president. Knudson has become one of 1225's "reverse career" members, as he began as a volunteer with 1225 and later left his job in the insurance industry to become a railroad engineer with the Burlington Northern Santa Fe Railroad in Kansas. Reversing the pattern from the 1970s, when active or retired railroaders became volunteers with Project 1225, several other members have joined Knudson in becoming professional railroaders after staring out with the 1225 group. (Courtesy SRI Collection.)

Chris Kurzweil is another board member who enjoys a dirty job. He grew up in the Chicago area and often visited a local Milwaukee Road roundhouse as a boy. After a successful career producing automotive tape, the Port Huron resident discovered PM 1225 and became an active volunteer, board member, and major donor. Kurzweil is seen here replacing a window on the Chicago & North Western combine car, currently used as a tool storage and crew car. (Courtesy SRI Collection.)

The creation of a permanent home and storefront presence in Owosso made it easier for people to find SRI and the 1225, and also attracted many new volunteers from the local communities. Neighbors Ron Miller (left) and Fred Stevens came to SRI from the village of St. Charles, and they were frequently car hosts on the family cabooses of the North Pole Express runs. (Jason LeBrasseur photograph; courtesy SRI Collection.)

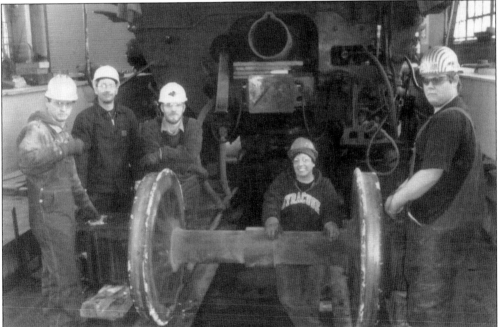

In an image similar to one in chapter one, the rear wheel of the trailing truck has been removed from under PM 1225's cab. It will soon undergo repair and eventual replacement of both its tires, which date to 1948. Seen here inside the Great Lakes Central's diesel shop in February 2009, (from left to right) Justin Hamilton, Mark St. Aubin, Diane Francis, Greg Udolph, and Steven McKay stand with the recently removed rear wheel. McKay is engineer Joe Sigafoose's grandson, and he has followed in the same tradition as his grandfather. Steven now works for the Marquette Railway in Ludington. (Courtesy SRI Collection.)

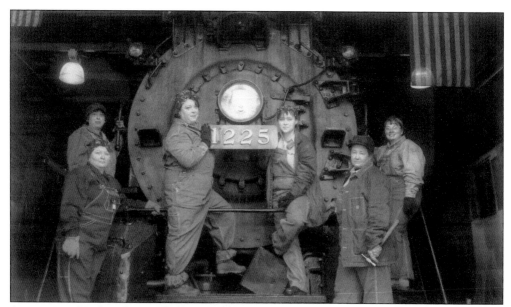

As mentioned earlier, chartered photograph trains have become a popular pastime for photography clubs as well as railfans. PM 1225 has hosted events from all regions of the country and as far away as Great Britain, and participants use vintage rail, farm, and automotive equipment to stage recreations of certain scenes from the past. Here, a few of the female volunteers at SRI don their best World War II–era clothing and strike "Rosie the Riveter" poses in front of the engine. From top left to top right are Diane Francis, Jane Unterbrink, Kim Lazar, Alaina Kraus, Kathie Barnett, and Heather Gaffney. (Pete Lerro photograph.)

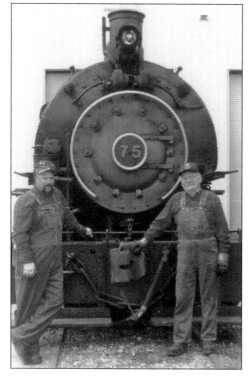

John and Barney Gramling thought it would be a fun to restore a small steam locomotive at their farm near Ashley, Indiana. After volunteering with the Little River Railroad in Coldwater, Michigan, they purchased the small tank engine Flagg Coal No. 75 from a collector's estate in Sandy Pond, New York. Rescuing it from an overgrown field, the father-and-son team spent 10 years restoring the engine. Their hobby project has now grown into a business, leasing and trucking two steam engines to tourist railroads and museums around the country. (Pat Gramling photograph; courtesy Gramling family.)

From left to right, Matt Foland, Barney Gramling, and Kevin Mayer pose in front of Mississippian No. 76 after removing the smokebox from the former Gettysburg excursion engine on February 25, 2006. After completing a degree in history, Foland became SRI's first full-time curator. Later, he would serve as executive director before moving on to a management position at CSX. Both Gramling and Mayer have served as chief mechanical officers of SRI. The 2-8-0 Consolidation locomotive was purchased by SRI for use as a more economical alternative for shorter trips, and it is currently being restored by the young men and women of Explorer Post 1225. (Jason LeBrasseur photograph; courtesy SRI Collection.)

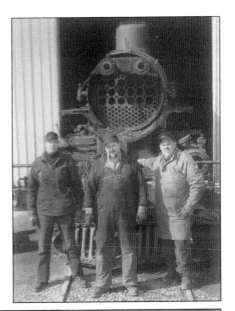

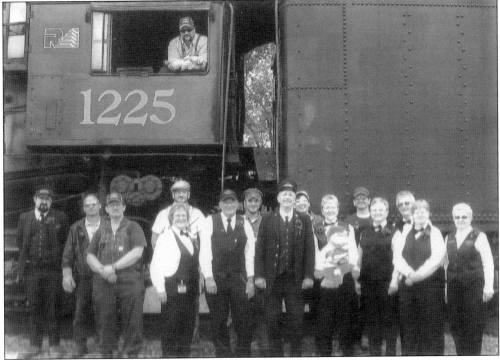

SRI has always tried to maintain good working relationships with the railroads on which it operates. Corporations or other groups occasionally charter trains for their employees or members. Here, on June 18, 2008, SRI volunteers and RailAmerica employees pose with 1225 during an employee special from Saginaw to Bay City. In the cab is Barney Gramling. From left to right are T.J. Gaffney, RailAmerica trainmaster Jeff Hopkins, Bill Wilson, RailAmerica conductor Zack Stieler, Sue Grieve, Bill Speer, Greg Udolph, Fred Stevens, Di Francis, Denise Porter (holding "George the Mascot"), Rob Gruich, Pam Shattuck, Maurie Shattuck, Jodi Hak, and Carole Stevens. (Courtesy SRI Collection.)

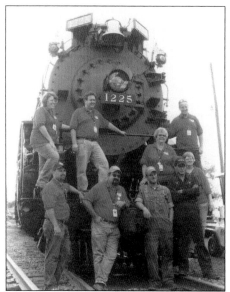

Train Festival 2009 was one of the largest gatherings of restored steam locomotives ever held in the United States. The four-day event drew more than 35,000 visitors and eight steam locomotives. Here, the event team poses with 1225. From left to right are (first row) Jason Johnson, T.J. Gaffney, Greg Udolph, Justin Hamilton, and Jodi Hak; (second row) Kim Lazar, Rich Greter, Sue Grieve, and Mark Perri. (Courtesy SRI Collection.)

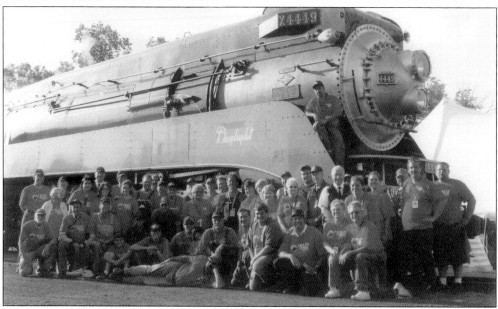

This book concludes with a few photographs of the heart of the organization: the volunteers who make all the events happen. Here, Train Festival 2009 volunteers pose in front of the beautifully streamlined 1941 Lima product Southern Pacific No. 4449, from Portland, Oregon. From left to right are Dean Pyers, Skip Vandermolen, Chris Gaffney, Bill Wilson, Fred Maynard, Ellen Williams, Bruce Kuffer, Heather Gaffney, Greg Schultz, Thomas Gaffney, unidentified, Anthony Clark, Justin Hamilton, Ryan Beck, unidentified, Rob Gruich, Greg Udolph, unidentified, Pat O'Brien, Dane Reynolds (with Phoebe Gaffney), T.J. Gaffney (front), John Hansen, Sue Grieve, Dave Potter, John Hansen (unlrelated), Rich Greter, Paul Hahn, unidentified, Kim Lazar, Jodi Hak, Tammy (Sigafoose) McKay, unidentified, Bill Speer, Carole Stevens, Dave Bennis, Steven McKay, Fred Stevens, Jason Johnson (on running board), Bob Thatcher, Pam Shattuck, Maurie Shattuck, unidentified, Diane Perri, John Barnett, Mark Perri, and unidentified. (Courtesy SRI Collection.)

SRI's car hosts represent the face of SRI to the public. Posing in front of one of two former Ann Arbor cabooses owned by SRI at the 2009 Melon Festival in Howell, Michigan, are, from left to right, T.J. Gaffney, Jane Unterbrink, Vicki Heckman, Barb VanEffen, Reinhard Hurt, Beth McGinnis, Parker Moon, Taylor Moon, Fred Maynard, Penny Green, Matt Kuffer, Denise Porter, Bruce Kuffer, John Hansen, Doug Cooper, Fred Stevens, Aaron Farmer, Christiaan Beatty, Chris Gaffney, and Bob Thatcher. (Courtesy SRI Collection.)

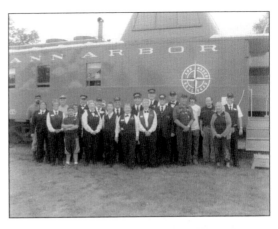

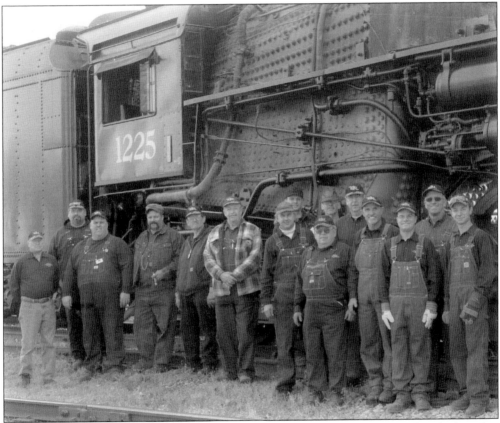

Every 15 years, steam locomotives are required to be fully inspected and have their boiler tubes replaced. From 2010 to 2014, nearly $900,000 and tens of thousands of volunteer labor hours were spent replacing 1225's boiler tubes and installing a brand new firebox. Winning a 2014 Governor's Award for Historic Preservation and carrying on the tradition of the long blue line of coverall-wearing boilermakers and students from the past 70 years, the shop maintenance crew poses with 1225 on November 20, 2013, the day the most recent rebuilding project ended. From left to right are Richard Sipp, Jeff Winarski, Kevin Mayer, Barney Gramling, Bill Wilson, Fred Stevens, John Grembowski, Rob Gruich, Larry Hyde, Paul Hahn, George VanDuyne, Dave Rudolph, Nick DeClerg, Earl Hayes, and Taylor Moon. (Heather Gaffney photograph.)

Current executive director David Shorter throws the first scoop of coal into 1225's new firebox in October 2013. (Courtesy SRI Collection.)

On May 12, 1973, David P. Morgan, the ever-eloquent editor of *Trains Magazine*, closed his remarks to the second-annual MSU Railroad Club Banquet with the following words: "For steam locomotives do not belong outdoors behind cyclone fences in parks, jackets rusting, headlight and cab glass broken, gruesome skeletons of the proud, live machines we knew in our youth. Steam locomotives were intended to boil water, produce ton-miles and train-miles, summon young men off the farm. And when—I reject the qualifying word "if"—when you have this handsome locomotive in steam, I can assure you that my wife and I will be here in Lansing at trackside. You won't see us. The crowd will be much too large for that. But we will be there. And, just because I have no alma mater, I may just privately adopt MSU as my school. For if this university adopts this engine, then this institution will have evidenced itself as truly a place of higher learning, learning not only of the trades, to recall Beebe's words, but learning of the heart." *See you trackside.* (Jeff Mast photograph.)

INDEX OF LOCOMOTIVES

BIBLIOGRAPHY

American Association of Railroads statistics, 1929–2002.

Million, Arthur B. and Thomas W. Dixon Jr. *Pere Marquette Power.* The Chesapeake & Ohio Historical Society, 1984.

Railroad History magazine, Issue 197, Fall–Winter 2007. The Railway & Locomotive Historical Society.

Trostel, Scott D. "Building a Lima Locomotive: The Steam Locomotive Construction Process of Lima Locomotive Works during 1924." Fletcher, OH: Cam-Tech Publishing, 1990.

———. *The Building of Lima Superpower.* DVD. Fletcher, OH: Cam-Tech Publishing, 2011.

Weitzman, David. *Superpower: The Making of a Steam Locomotive.* David R. Godine, 1987.

www.limalocomotiveworks.com

www.pennsyrr.com

Zapiecki, Tom. *Made in America: Lima Locomotive Works.* DVD documentary. Bowling Green, OH: WBGU-TV, 2013.

DISCOVER THOUSANDS OF LOCAL HISTORY BOOKS FEATURING MILLIONS OF VINTAGE IMAGES

Arcadia Publishing, the leading local history publisher in the United States, is committed to making history accessible and meaningful through publishing books that celebrate and preserve the heritage of America's people and places.

Find more books like this at
www.arcadiapublishing.com

Search for your hometown history, your old stomping grounds, and even your favorite sports team.

Consistent with our mission to preserve history on a local level, this book was printed in South Carolina on American-made paper and manufactured entirely in the United States. Products carrying the accredited Forest Stewardship Council (FSC) label are printed on 100 percent FSC-certified paper.

MADE IN THE
USA